A memento for my daughters
Catherine and Joanna

First published in 2002 by Redcliffe Press Ltd.,
81g Pembroke Road, Bristol BS8 3EA

Telephone: 0117 9737207
Facsimile: 0117 9238991

© text: Douglas Merritt
© photographs: Public Monuments and Sculpture Association
 and Stephen Morris

ISBN 1 900178 83 4

British Library Cataloguing in Publication Data:
A catalogue record for this book is available from the British Library

Design: Douglas Merritt ARCA FSCD

Printed by HSW, Tonypandy, Rhondda

Douglas Merritt

Sculpture in Bristol

Photographs by Stephen Morris and Janet Margrie

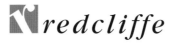

Contents

Commemorative sculpture and monuments

*The sculptures and monuments
are presented under four categories
in the chronological order
in which they were erected in the city*

Sculpture and monuments in Bristol

I have long wanted to publish a guide to public art in Bristol. Three years ago I planned for Redcliffe Press a series of studies of the city's art and architecture. *C20: Twentieth-Century Buildings in Bristol*, published with the Bristol Architecture Centre, set the standard; *A Bristol Eye* and *Bristol Before the Camera: The City in 1820-1830*, the book of the Braikenridge exhibition at the Bristol Museum and Art Gallery, followed in 2001. My proposed sculpture book would be in good company.

Through Andrew Kelly's good offices, sponsorship funds then became available to make the sculpture project viable. At the same time, I got to know Professor Douglas Merritt, who had worked with the Public Monuments and Sculpture Association to build up an astonishing archive on Bristol and the south-west of England. Not only was his research well advanced but he was clearly better qualified than I to write the book. Douglas readily agreed that it should appeal as much to the casual visitor as to the serious student of public art. He has produced a model of its kind.

Without financial backing, publication in this form would have been quite uneconomic. I therefore have great pleasure in acknowledging generous support from Mr Louis Sherwood; Bristol Chamber of Commerce & Initiative; Mr Alastair Brook, Team Manager, Environment, Transport & Leisure Planning Services, Bristol City Council; Public Art South West and South West Arts.

John Sansom April 2002

Foreword

In recent decades 'public art' has had a mixed press. One eminent British architect likened the attempts to use large sculpture to prettify bleak urban spaces to putting 'lipstick on a gorilla' – a pointless exercise in civic self-aggrandizement. This is however to simplify an extraordinarily complex process involving planners, fund-raisers, commissioners, civil authorities, and, occasionally, the artist. Public sculptures and monuments never come about by accident. They are a physical manifestation of competing interests and ideologies. Monuments are the pivotal elements in the symbolic topography of every city. The statues, memorials, obelisks and other rhetorical furniture function as forms of civic art that help to contain and convey different levels of memory. Who exactly determines and controls that memory is one of the more fascinating, but rarely considered, aspects of a city's history.

As is evident in this very necessary survey of the public art of Bristol, its monuments, statues and memorials have rarely been sited without some consideration of their role in a symbolic landscape. Witness, for example, the furore over the location of the municipal memorial to the dead of the Great War.

It is to the credit of Professor Merritt and the Public Monuments and Sculpture Association that we have the present volume to illuminate us all, to shed light on some of the sculpture and the 'large jumble room' that constitutes our furnished city.

Professor Paul Gough, *University of the West of England, at Bristol*
Paul Gough was Chair of the PMSA's South West Regional Archive Centre

Towards 2008

Good cultural cities are made up of many things. Cinemas, galleries, museums and theatres are all important. I know I am in a great city when I find walking around it as moving as looking at a great painting, a film or a play. Jane Jacobs in *The Death and Life of Great American Cities* said, 'Think of a city and what comes to mind? Its streets. If a city's streets look interesting, the city looks interesting; if they look dull, the city looks dull.'

From the traditional statue to the most experimental installation, public art provides life to the city, always interesting, often challenging, sometimes amusing.

Bristol is now engaged in making a bid to be the 2008 European Capital of Culture. Urban design is important as it is the most immediate though least apparent cultural experience of all. It is the culture of the every day, which we all experience whether it is architecture, transport, planning, housing, parks and gardens. It creates a city welcoming to all, provides safe and animated squares and spaces, and uses lighting creatively, with plaques and signs providing details of city history.

Art is essential to cities. We want to see more public art. *Sculpture in Bristol* – a walk around the glorious public art of Bristol – shows what the city has, and provides inspiration to us all to create more public art in the future.

Andrew Kelly *Director, Bristol 2008*

Introduction

Among the pigeons – rather than in an art gallery – is a very vulnerable place for art to be.

Making sculpture for the public arena always imposes constraints on the sculptor's choice of materials, on the form of the work and on the techniques required. All these have to be selected to combat the ravages of weather and vandalism. By contrast constant surveillance and the controlled light levels of an art gallery allow the artist unlimited freedom.

And yet, Walter Ritchie, sculptor of the relief panels on the Bristol Eye Hospital, chose to have only two gallery exhibitions in his whole career. He maintained the best place for sculpture was in the public domain and cited Lewis Mumford, American writer on urban planning and architectural critic, in support of his view.

Writers on the history and the architecture of Bristol, and most guidebooks, make references to the statues and monuments of the city but no study concentrating on the city's outdoor art gallery has been published.

Much of the sculpture in Bristol is discrete – gently inviting rather than accosting – and there are unexpected sculptures and memorials to be found when walking in city spaces, parks and harbour-side.

Few grand vistas exist where sculpture dominates. Ancient and modern mingle haphazardly. Each site was conceived in isolation. There has never been a sustained period of city planning.

Through the past three centuries the major force in the proliferation of public sculpture has been the determination of groups and individuals to realise their ambitions.

The work presented here has been selected from a survey of Bristol made in the past five years on behalf of the Public Monuments and Sculpture Association to record all public sculpture in Bristol at the start of the twenty-first century. The Faculty of Art, Media and Design of the University of the West of England generously contributed to that research project.

As in all cities, the history of Bristol is reflected in its statues and monuments but there has never been a coherent strategy. The miscellany of sculpture recalls royalty, politicians, the discoverers of the New World, and the industrial expansion of the city – once the second largest in the kingdom.

Statues, monuments and fountains in the public domain are the result of haphazard enthusiasms for a wide range of causes. The dominant factor has been the desire to preserve ideas and memory in a tangible form.

Planning public sculpture

Gaining public support is an early stage. Those with ambitions to erect public sculpture next need to persuade the City Council to consent to their plans and work with them to achieve their aims.

On some occasions attempts to raise public funds have brought only minimal results. Companies or individuals have then come to the rescue with financial support. Sometimes wealthy individuals or companies have presented sculpture as a gift to the city without any public contribution. The modern patron is society itself, working through a quango or local committee to raise public funding. From placing the commission for a sculpture to the unveiling is usually a long and difficult process. A recent example: at the beginning of 1996 The Merchant Navy Association of Bristol resolved to set up a memorial to merchant seamen who lost their lives in the Second World War. Choosing an architect,

a sculptor and the site was a complex task. Five years passed before the monument, designed by David Backhouse, was unveiled in 2001 on Welsh Back – the second site to be considered.

Settings are vital; they diminish or enhance any sculptural work. Bristol's most prestigious setting is Queen Square, where Rysbrack's masterful equestrian statue of King William III remains the jewel in the crown.

Here we have an *English* King, who was *Dutch*, heavily disguised as a *Roman* Emperor, brilliantly portrayed by a sculptor from *Antwerp*. Rysbrack's biographer, M. I. Webb, felt his Bristol masterpiece was 'too little known, for it may claim to be easily the best statue in England. If it were in a provincial town on the continent sightseers would go a long way to see this.'

Queen Square, built at the end of the seventeenth century, was on a grand scale from the very beginning. A lithograph of October 1831, by the Bristol artist William Müller, shows how close the statue came to destruction in the Bristol Riots.

Now the surroundings have been elegantly restored. A road, cut diagonally across the space in the 1930s, spoilt the site. In the recent restoration it has been removed.

Another civic scheme that used sculpture to great effect was the *King Edward VII Memorial* outside the Victoria Rooms. This was constructed between 1910 and 1917 under the aegis of Alderman Christopher S. Hayes, Lord Mayor of Bristol. From the outset he intended to produce an exceptional setting for the statue of the King. The architect he appointed designed a setting that included a fountain, flagpoles, lamps and lions.

The Memorial Committee had the courage and foresight to commission this elaborate improvement to the appearance of the city. The result was practically without precedent in the country at that time, at least as far as the provinces were concerned. The legacy was a plan that ranks with many of the best continental schemes of that period and remains a great example of the work of the architect, E. A. Rickards, and the sculptor, Henry Poole.

The once imposing setting on College Green, created for the statue of *Queen Victoria* for her Golden Jubilee year of 1887, has been diminished every time the statue was moved.

Finding a site for the *Cenotaph* (1932) was an intractable and, at times, a bitter affair. Alternative spaces were argued about over a long period. Old Market, The Horsefair, a site on the Downs, and removing *Queen Victoria* from College Green – were all considered in the search for a place to honour the city's war dead.

Castle Park, commenced in 1990, was based on a plan created by Lesley Greene, an arts advisor appointed for three years by Bristol City Council. She then commissioned sculpture for this area of the city, virtually destroyed by Second World War bombing. In a place in which to relax Peter Randall-Page's sculpture, *Beside the Still Waters* (1993) and other works create a peaceful setting in an otherwise hyperactive part of the city.

Millennium Square, the most recent example of a planned urban space, has added much new sculpture. A large innovative fountain, *Aquarena* (2001) by William Pye, forms a dramatic entry to the square where children play in the water. Laurence Holofcener's three statues reject the formality of pedestals.

Bristol City Council appointed Alistair Snow as its first Senior Public Art Officer in 2001 and his task is to encourage the commission of public art as part of the planning and development

process and create a long-term strategy for public art in Bristol.

The last statue to be erected before going to press was the bronze of *Cary Grant*. He has been given a position in Millennium Square and this celebration of Bristol-born Archie Leach will intrigue visitors from all over the world.

The time span of Bristol's sculpture
Hardly any sculpture remains from the Middle Ages, other than work in, and on, churches. A small, seated, Virgin Mary remains under an arch at the foot of Christmas Steps on the site of St Bartholomew's Hospital. Although much decayed, Nikolaus Pevsner linked this to sculpture on the façade of Wells Cathedral.

Four medieval statues, removed from the city walls, were placed on Arnos Vale Gate in 1764. They were taken in to Bristol Museum in 1912. Copies have been made in the past few years and these are now on the restored gateway.

Very little sculpture of significance was in place until the early eighteenth century when the lead statue of *Neptune* was erected at the Temple Conduit in 1723. Then Rysbrack's masterpiece, *William III*, arrived by sea from London in 1736. Another lead giant is the statue of *Hercules,* probably taken some time between 1758 and 1768 from King's Weston House to Goldney House. This was recorded in an inventory at Thomas Goldney III's death in 1768.

In the early nineteenth century Baily's *Minerva* (1823) appeared on the Masonic Hall at the bottom of Park Street and *The Goddess of Wisdom* (1840), a decorative relief, was carved in the pediment of the Victoria Rooms. But it was not until later in Victoria's reign that the scene was enlivened by a wider range of work.

The sculpture-encrusted façade of Lloyd's Bank appeared in Corn Street in 1854 and The Royal West of England Academy building contributed the statues of *Flaxman* and *Reynolds* in 1857. Statues of *Samuel Morley* (1887), *Queen Victoria* (1888), *Edmund Burke* (1894) and *Edward Colston* (1895) followed.

This was the era that Bristol historian Bryan Little praised when he wrote 'Bristol is distinctly better off for public statues than provincial cities of similar or even larger size. Royalty apart, some of the city's statues commemorate famous men of much more than local note and some have artistic merits higher than one would normally associate with such tribute'.

In the early twentieth century the *Gloucestershire Regiment Boer War Memorial* (1904) in Queen's Road, so often despoiled by pranksters, the figures on the Museum and Art Gallery (1905), Pibworth's reliefs on the Central Library (1906) and the *King Edward VII Memorial* (1910-17) were added.

Throughout the twenties and thirties few other monuments or sculptures of significance were erected on prominent public sites. The Clifton College statue of *Earl Haig* (1931) and the statues of the two *Wesley* brothers are on private property but the public is able to see them. The First World War had produced little but the need for more memorials to the war dead. Bristol's *Cenotaph* was not unveiled until 1932, delayed while arguments raged about the most suitable site.

Recovery from the Second World War was slow and the flow of new work did not commence until the mid-1970s. Exceptions created in this sparse period were Bristol's two golden *Unicorns* (1950) on the Council House roof and the *Elizabethan Sailor* (1952) in its central porch.

Statues on the move

Statues evoke permanence but a number of those in Bristol have already been moved several times; the most frequent reason has been increasing traffic and new road layouts. Some of these moves occurred surprisingly early. *Neptune*, first erected in 1723, has been moved six times. *Samuel Morley* (1887) has had four settings and was first moved, due to congestion, as early as 1921. The statue of *Queen Victoria* (1888) has made three moves on the ever-changing College Green.

Off the beaten track

Six large relief panels of *St Francis of Assisi* (1974) by Judith Bluck typify the more concealed sculptures in the city. These are hidden on a shaded wall of an office block, Greyfriars, the site of the Franciscan foundation at Lewins Mead. Sunlight illuminates them very briefly in the early morning. Only those using the building are likely to be aware of them.

Horse and Man (1984) by Stephen Joyce is even more secluded. This sculpture is well worth a visit and can be seen by those bold enough to wander through gates into a courtyard off St George's Road, behind the Council House.

Few shoppers in the busy Broadmead area notice the bronze statue of *Charles Wesley* (1936) by Frederick Brook Hitch, or A. G. Walker's equestrian statue of Charles's brother, *John Wesley* (1931). They are both away from obvious public view on land inside the confines of the Wesleyan chapel, known as the New Room.

The fountain of *Sabrina* (1989), by Gerald Laing, is another work not easily found. His four bronze figures are secluded in the courtyard contained by Broad Quay House.

The open-air art gallery

If the setting of public sculpture is considered to be an open-air art gallery there is, unfortunately, no catalogue to tell us about the works on display.

The provenance of sculpture, paintings and other artefacts in public galleries and museums are, in contrast, meticulously labelled.

Only rarely is sculpture in the open-air adequately labelled. All too often we have to assume what the sculptor intended or guess the subject and ponder what the purpose was, all without information. Few sculptures present the name of the sculptor in a clear manner or give the date the work was erected.

All three sculptures on Baltic Wharf, erected about fifteen years ago, do have titles but none of them is given on the site. Each would help viewers to engage with the works. None of them is dated. One, a large bronze hand, does have the sculptor's name but in lettering barely half a centimetre high. There is no clue to the ideas the sculptor wished to convey. The whole process can seem part of the Official Secrets Act.

Without information, myths and speculation are more likely to become facts. These spread and they can be believed for many years. *Neptune* was accepted as a celebration of the defeat of the Spanish Armada in 1584. This became 'official'. In 1872 an inscription repeating the wild Armada story was fixed to the pedestal. In fact, the lead giant was not made until 1723. The inscription did not change until *Neptune* was moved from Temple Street to the City Centre Bridgehead in May 1949 when the present plaque was fixed and the correct history of the statue was properly presented.

The purpose of this book

The texts try to describe why each work was erected and who was responsible for its creation. Accounts of what, or whom, the works represent are also given.

The author's opinion on the aesthetics and the quality of the work has not been given. As Bryan Little wrote, in the introduction to his *The City and County of Bristol* first published in 1954, 'I have my dislikes and my preferences . . . but I hope that these have not interfered with my recording of the essential facts'.

Notes on the lives and skills of the sculptors are presented at the back of the book. Among Bristol-born sculptors are Edward Hodges Baily, creator of the statue of *Nelson* in Trafalgar Square, and James Havard Thomas. Both of them have work in Bristol Cathedral – Baily has a bust of the Bristol-born Robert Southey and Havard Thomas has memorial reliefs to Mary Carpenter and to Christopher James Thomas. Charles Pibworth, creator of the three large reliefs on the Central Library, was born in Southville. Stephen Cox and Stephen Joyce were born here. Joyce has contributed more works to Bristol than any other sculptor.

There have been a number of émigrés from Europe – Rysbrack in the eighteenth century and Sir Edgar Joseph Boehm in the nineteenth. In the last century Paul Vincze came from Hungary and Franta Belsky from Czechoslovakia.

What comes immediately to mind when public sculpture is mentioned? First thoughts are often of bronze or marble statues – generals and politicians on pedestals – but the modern art movement has radically changed that assumption and the variety of public sculpture is now very diverse. Use of cast or carved human figures has declined and more creative ways are explored.

Small Worlds (2001) by Simon Thomas, in Anchor Road, Canon's Marsh, commemorates the achievements of the Bristol-born Nobel Prize winner Paul Dirac and demonstrates an alternative to a 'portrait' statue by constructing a complex cone to visualise a concept of quantum mathematics. The explanatory plaque is small and so far away from the sculpture that few people will discover it, or connect the plaque to the cone. *Small Worlds* and the naturalistically painted bronze dogs in Millennium Square take the normal expectations of public sculpture to extremes.

Cat among the pigeons

'Public' combined with 'art' can be very explosive. Dissent of some kind surrounds every work erected. Timing, taste, cost, aesthetics, politics, and the site – all can cause offence.

Bristol's *Cenotaph* (1932), the gilded *Unicorns* (1950) on the Council House, the statue of *Queen Victoria* (1888), *Brunel* (1984) outside the former Bristol and West building at Broad Quay and the recent the tribute to *Cary Grant* all prompted discord. The conflicts are usually complex, often dramatic and occasionally humorous.

The machinations behind the competition to find a sculptor for the statue of the King Edward VII memorial were revealed in recently found files in the Bristol Record Office. The City Clerk of Works carefully monitored the making of the memorial over a period of seven years. Documents range from letters written by many of the most able sculptors of their time – some of whom declined to enter the competition for the statue – to a bill for £7. 19s . 0d from John Harvey and Sons for the champagne, wine and whisky drunk at the Victoria Rooms on the day in 1913 when

King George V came to see, but not to unveil, Bristol's tribute to his late father.

One of the sculptors invited to take part in the competition to design the statue of King Edward VII was Captain Adrian Jones, MVO, a retired veterinary surgeon from the Hussars. He had made the equestrian statue of General Sir Henry Redvers Buller (1905) at Exeter and the vast horses on *Peace* (1912) on the Wellington Arch at Hyde Park Corner. Jones wrote a disdainful refusal when he discovered Bristol had decided their statue of Edward VII would <u>not</u> be in the equestrian style. 'Unfortunately the form you have decided upon precludes me doing so. I cannot bring myself to portray a King, such as Edward was, as a standing figure such as is normal to commemorate a Politician.'

Creating and caring for sculpture and monuments
Local government permission is required for the installation of the majority of street sculpture. With that power comes the responsibility for the local authority to maintain the public sculpture it owns. In the past few years Bristol City Council has achieved a great deal of conservation and repair.

Recently, plans in America have been formulated whereby permission will be granted for new sculpture only if the sponsors enter into a covenant for future maintenance.

Over the past twenty years development schemes, such as at Baltic Wharf, have devoted a portion of the building costs to create public sculpture using a 'Percent-for-Art' policy.

No official directory of public sculpture exists. In many towns and cities local records are inadequately researched, poorly maintained and rarely available to the public. The Public Monuments and Sculpture Association intend to publish CD-roms containing the information for the whole country.

Stone and bronze are remarkably resilient materials but all outdoor work is constantly deteriorating. Only by removing it from the atmosphere can this process be slowed. The bronze equestrian statue of the Roman Emperor, Marcus Aurelius, was exposed to Rome's atmosphere for 2,000 years before the Italian government had a replica made in the early 1990s. The original was taken from the centre of Campidoglio for cleaning and conservation and then placed inside an adjacent museum. A copy, made with computer-controlled precision, using glass fibre and resin has been installed in its place.

Rysbrack's masterpiece, *William III*, has been open to the elements in Queen Square for 266 years – except for the brief period when it was removed to Badminton House in the Second World War. This and other bronze* sculptures in Bristol have recently been given a modern treatment, widely applied in most European cities and in America. The surface is coated with layers of synthetic wax and acrylic resins.

The public view?
We may admire the sculpture of Paris, Rome, Vienna, or wherever else we travel, and delight in such wonderful sights. Their creation and maintenance does not fall on *our* rates. When the cost of conserving and caring for similar treasures in our own cities arises

* William III has recently been analysed as brass. See page 16. Bronze is a copper/tin alloy and brass a copper/zinc alloy. Wax shields prevent the familiar green patinas, associated with bronze statues, from forming.

we can be both critical and hypocritical about the cost. 'A load of old stones' a Bristol councillor declared when a Victorian fountain required conservation work.

Bristol's lost sculpture
Sculptures disappear and knowledge of them fades. A statue of George III, erected in Portland Square in 1810, did not last long. Within three years, on the night when Henry Hunt made a speech outside the Exchange in Corn Street, a group of protestors managed to pull down the Coade stone* statue from its pedestal and smash the figure beyond repair. Hunt addressed 60,000 people assembled in Manchester in1819 when 11 were killed and 500 injured in the Peterloo Massacre. One man, John Harris, served a year's imprisonment for the Portland Square incident.

Political agitators and vandals were not the only people guilty of depriving Bristol of public monuments. In 1768 the Dean of Bristol Cathedral notoriously gave the city's original High Cross, erected to celebrate Edward III's Charter of 1373, to the banker Henry Hoare. Hoare re-erected the cross in his Palladian garden at Stourhead, in Wiltshire. The Rector at Stourhead was the Dean's brother. English Heritage has recently restored this early Bristol treasure. Stourhead also managed to acquire St Peter's medieval fountain from the area of Bristol that became Castle Park. This ancient fountain now marks the source of the River Stour.

At one time a stainless steel sculpture called *Skysails* (1974) by Paul Mount, sculptor of the *Spirit of Bristol*, enlivened a wall on Brigstowe House on Welsh Back. *Skysails* was acquired in 1998 by the University of Exeter for a building on its Streatham Campus.

More recently the city centre has lost another large sculpture. *Southern Ellipse* (1980), by John Maine, had been outside the Sun Life Assurance Building at Haymarket for over 20 years but was taken to enhance their new offices at Stoke Gifford in 2001.

Do we take much notice or enjoy the sculpture we have inherited? A decade ago Richard Lee, a Bristol architect, proposed an open-air biennial festival using the city's open spaces, parks and quaysides with a clear focus on sculpture. Since then a great many changes have been made in the city. Some areas have been altered and some new ones created. Many spaces in which sculpture is featured could provide stages for drama and music. Queen Square rivals many public spaces in Europe. At Brunel House in St. George's Road there is an arena around Stephen Joyce's *Horse and Man*. We could make more use of these spaces.

On being asked to name any statue in Bristol most people have struggled to recall three. Perhaps this account will encourage greater awareness.

The American singer Joni Mitchell wrote a song entitled *Big Yellow Taxi* in which she said:

> 'Don't it always seem to go
> That you don't know what you've got
> Till it's gone
> They paved paradise –
> And put up a parking lot.' *

* Mrs. Eleanor Coade manufactured this remarkably durable artificial stone in Lambeth, London, from 1769 to 1833.

Douglas Merritt, Clifton Spring 2002

* © 1970 Siquomb Publishing Corp. BMI

13

'The city, as one finds it in history,
is the point of maximum concentration
for the power and culture of a community.
It is the place where the diffused rays
of many separate beams of life fall into focus.'

'Here is where human experience is transformed
into viable signs, symbols, patterns of conduct,
systems of order.'

LEWIS MUMFORD (1895-1990)
The Culture of Cities

Commemorative sculptures and monuments

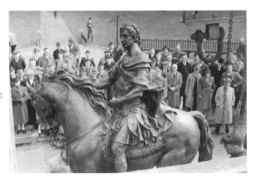

William III returns to Queen Square after removal to Badminton during the Second World War and (right) the restored setting in 2001.

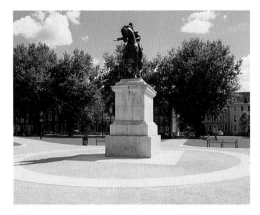

1
William III

Michael Rysbrack

City centre
Centre of Queen Square
Erected 1736
Brass on a Portland stone pedestal
Owner: Bristol City Council
Listed Grade I

Newly carved in the paving round the statue is:
'THIS INSCRIPTION COMMEMORATES THE
RETURN OF THIS HISTORIC SPACE TO THE
CITIZENS OF BRISTOL. THE WORK WAS
COMPLETED IN THE YEAR 2000 THROUGH THE
SUPPORT OF THE HERITAGE LOTTERY FUND,
BRISTOL CITY COUNCIL
& THE QUEEN SQUARE ASSOCIATION.'

'William III was not a popular King. It is all the more remarkable therefore that this much maligned monarch should, after his death, have become the subject of numerous public monuments of which the one in Queen Square is surely the finest.' A frequently made claim, but here the commentator was curator Katherine Eustace when she prepared an exhibition on Rysbrack for the Bristol Museum and Art Gallery in 1982. English Heritage list the statue Grade I as 'an outstanding example of Rysbrack's work'.

The Bristol Common Council and merchants of Bristol were aroused when plans to erect a statue of William III (1650-1702) started in London. They saw an opportunity to get the better of the rival city and acted quickly. On 8 December 1731 'a great number of gentlemen and other inhabitants' voted to subscribe to 'the memory of our Great and Glorious Deliverer the late King William III'. People 'cheerfully' contributed 'towards erecting in Queen Square a fine equestrian statue in brass'.

On 8 July 1735 a London newspaper, the *General Evening Post,* said 'Yesterday the famous Equestrian statue of King William III cast in Brass by Mr. Rysbrack, the famous Statuary, was put on board Ship in the River in order to be carried to Bristol'.

Early references to *brass* have recently gained significance. Bristol University carried out a scientific analysis in 1999. This shows the metal of the statute is indeed brass (copper and zinc) – not bronze (copper and tin), as is more usual.

Rysbrack's earliest work in Bristol was a monument to Andrew Innys in St John the Baptist, made in 1726. Through his connection to Innys, a former Master of the Merchant Venturers, he may have been introduced to the competition for the William III statue.

Rysbrack's only rival was another émigré, Peter Scheemakers, also from Antwerp, and they both submitted models in 1732. The town of Hull purchased Scheemaker's design and, still gilded, it is in the Market Place there.

Rysbrack's monarch is in Roman costume, victorious, unarmed and peaceful. The pose and dress are similar to those of the statue of Marcus Aurelius in the Campidoglio, Rome. Rysbrack owned a copy of a book by François Perrier, published in 1638, showing two engravings of that statue – a front and a rear view – and an ideal reference for a sculptor.

Bristol's most prestigious public statue was restored to its original position in the redeveloped Queen Square in 2000. □

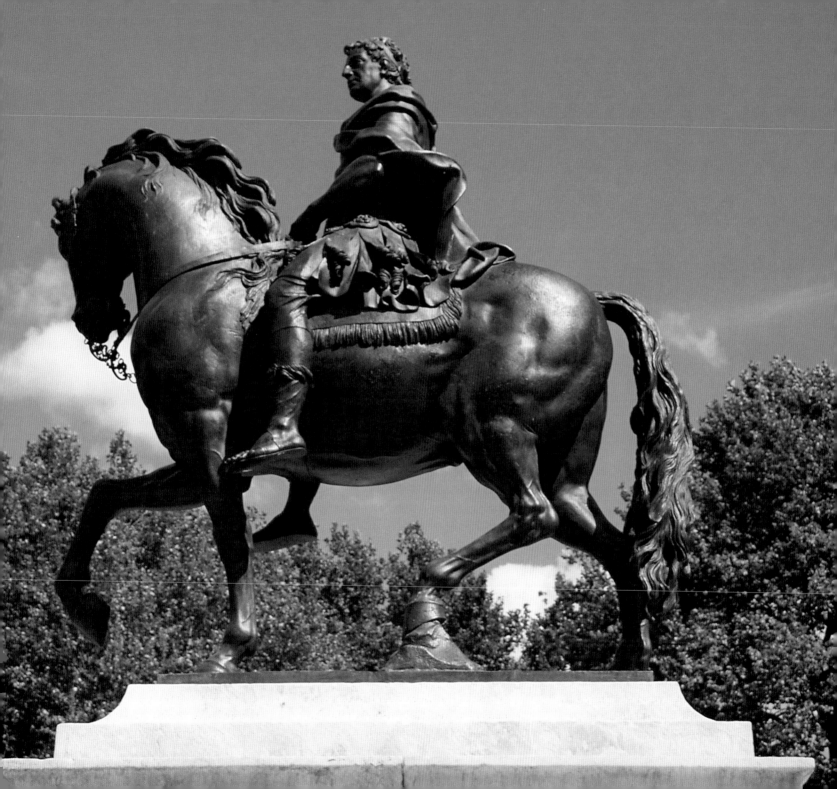

2
79th Regiment of Foot

Designer unknown

Clifton Downs
at the junction of Clifton Down Road
and Suspension Bridge Road
1767
Limestone with slate and copper panels
Owner: Bristol City Council
*Listed Grade II**

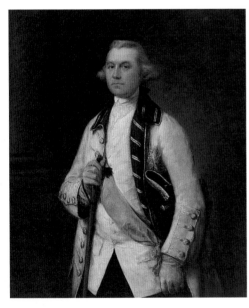

Fine Arts Museums of San Francisco Gift of Miss Else Schilling

Portrait of Lieutenant-General Sir William Draper,
painted by Thomas Gainsborough in Bath. c.1765

This is reputedly the oldest public war memorial in the United Kingdom.

The long inscriptions on this cenotaph contradict the view that public monuments and sculpture rarely give enough information. This military memorial bombards us with facts.

One panel, added when the memorial was moved to its present site, tells us Lieutenant-General Sir William Draper (1721-1787) erected the tribute in the garden of his house, Manilla (sic) Hall, on the site of which Manilla Road now stands. He wished to demonstrate his loyalty to the city of his birth and the 22 officers and men who died fighting with him. The inscription also says he was born in Bristol in 1721, that in 1744 he was elected a Fellow of King's College, Cambridge and that he chose a military rather than an academic career.

Draper raised the 79th as his own regiment during the Seven Years' War and commanded the force in the capture of the Spanish colony of Manila in the Philippine Islands in 1762.

By remarkable good fortune the monument was saved from destruction by Dr John Beddoe and moved to the present site when Manilla Hall was purchased in 1882 by a French Roman Catholic sisterhood. Manilla Hall was later demolished.

The memorial became a war casualty when shrapnel pitted it during bombing in the Second World War. In 1951 its restoration cost £200, shared equally between the War Damage Commission and Bristol City Council.

In the text are the unusual words 'BRITISH CONQUERORS'. There is praise for 'generous treatment of a vanquished enemy', for their 'moderation' and 'humanity' and they are also commended to future generations.

Draper's lifelong friend from Eton and King's College Cambridge, the poet Christopher Anstey (1724-1805), drafted the long Latin inscription. Anstey had achieved literary celebrity in 1766 as author of the *New Bath Guide*, a satire on the life in that city. He also composed the epitaph for Draper's memorial in Bath Abbey in 1787.

In 1766 the Society of Merchant Venturers appointed Sir William to be the Keeper of Clifton Down. He may have been responsible for the older trees planted on this spot. □

A Latin inscription on the cenotaph *(detail below)*,
written for Draper by Christopher Anstey, says:

*Stay your step, O, Wayfarer, if for Britons you have any care.
Stay your step that you may consider inscribed upon the empty
monument the melancholy fate of men whom their own warlike
ardour sent to the East never again, alas, to return. Nor should
you be ashamed to mourn if perchance you read the familiar
names of your own but by land and sea reflect upon the invincible
spirits and the deeds of heroes if love of Country, if Britain's fame
moves you. Forbear to scatter tears upon triumphal laurels rather,
if you are prepared to penetrate the deepest parts of Asia, uncover
Ganges' inmost bounds and smite Indus with war, then from
these you may learn valour and true toil — from others luck.*

Translation: Professor Alan Ryder, University of Bristol

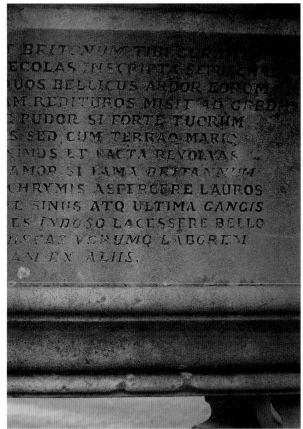

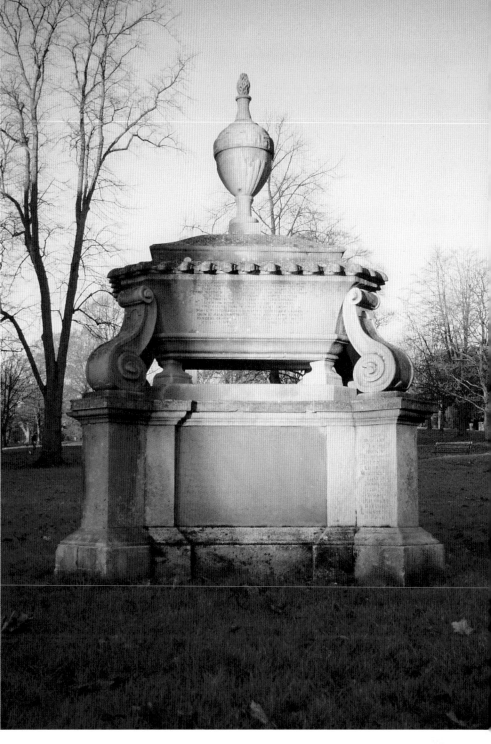

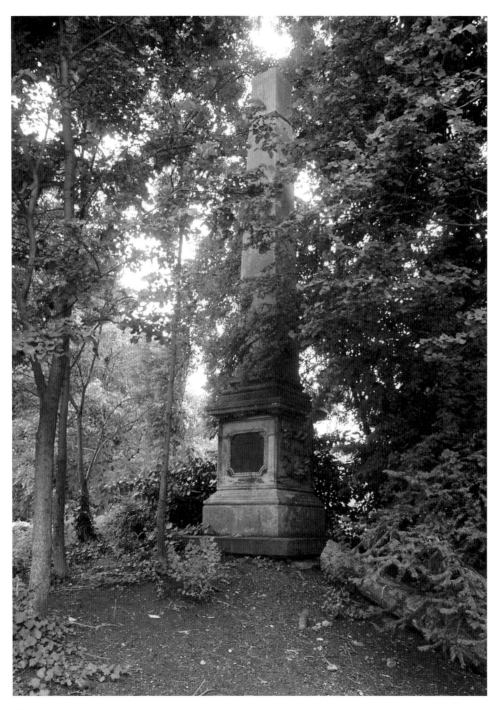

3
Princess Charlotte

Architect unknown

Redland
in the rear garden of what is now called
Queen Victoria House, Redland Hill
Erected soon after November 1817
Limestone
Owner: In the care of Kennedy & Donkin Limited
Listed Grade II

An obelisk now surrounded by trees is among the most concealed monuments in Bristol. Trees and shrubs have been allowed to obscure this poignant memorial to the extent that they are in danger of weakening the foundations. But it tells an unexpected story of an ill-fated Princess. She died when giving birth to a stillborn son at the age of 21.

This led to great public mourning that can be compared to the death of Princess Diana. On 7 November 1817, the day after Charlotte died, the leading article in the *The Times* said, 'we never recollect so strong and general an expression and indication of sorrow'.

A wealthy Bristolian, Jacob Wilcox Ricketts (1780-1846), was so affected that he had this large memorial erected in the garden of his home, Vincent Lodge at Redland. Ricketts was a banker who owned the Phoenix Glass

Company and had brewery interests. He was a Whig who had such hope in this Princess that the inscription says 'Thus were the Vine and Branch of true Whiggism and Britannia's most blooming expectation, by one irresistible stroke, together cut off'. This small copper plate disappeared in the early 1980s but surprisingly it was found and restored.

Princess Charlotte (1796-1817) was the only child of the Prince Regent (later King George IV) and she was heiress presumptive to the throne. To her father's disapproval she ended her engagement to Prince William of Orange because she feared her absence from England might affect her succession.

When she married Prince Leopold of Saxe-Coburg she was only 20. On her death in November 1817 there was no other surviving legitimate descendant from any of George III's thirteen children. Sir Richard Croft, the doctor who attended her, committed suicide.

Her death troubled the Royal family and three of George III's sons were hurriedly married by 1818 to produce an heir and ensure the survival of the House of Hanover. The Duke of Kent fathered Princess Victoria by 1819 and she became next in the succession.

In spite of Charlotte's position as a potential Queen of England and the awful circumstances of her death no other public memorial to the Princess has ever been raised although she was buried in St George's Chapel, Windsor.

Queen Victoria came to Bristol in 1899, during her Diamond Jubilee celebrations; one engagement was to open the convalescent home, built on the site of Vincent Lodge.

Would she have been aware of the obscure tribute in the garden and its dedication to her cousin whose untimely death led to her birth and the Victorian Age? □

Had Princess Charlotte not died in childbirth she may have become Queen. This Bristol monument is the only public memorial to celebrate her life.

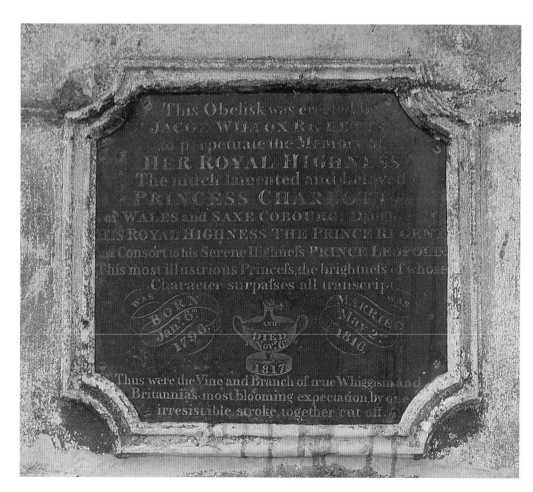

4
Flaxman and Reynolds

John Thomas

Queen's Road Clifton
Façade of the Royal West of England Academy
Erected c.1857
Two figures cast in cement on slate armatures
Owner: Royal West of England Academy
*Listed Grade II**

A large re-building and renovation project was commenced by the RWA during 2001 and, as part of this, these statues will be made far more accessible by the creation of a terrace café.

Exposed, high in their niches, for nearly a century-and-a-half they had become badly weathered. Careful cleaning and conservation will be required to preserve them.

The Trustees responsible for the building of the Academy in 1854 considered designs submitted by two local architects – Charles Underwood and John Henry Hirst. Very unusually they chose Underwood's design for the interior and Hirst's design for the exterior. It was Hirst who commissioned the Gloucestershire-born John Thomas (1813-1862) to provide the sculpture for his façade. Building costs went over budget and subscriptions were sought to purchase these two additional statues.

It has been suggested that Thomas may not have made these figures himself as he was superintending the stone carving for the entire Houses of Parliament at the time they were

made. However, Thomas's name is very boldly displayed on the Reynolds statue. The recent inspections show all the sculptures on the façade are castings, which was cheaper and quicker. It had been assumed they were carved.

More of Thomas's prolific output can be seen in Bristol. He has *Queen Victoria* and *Prince Albert* and other figures on the old Guildhall (1843-46) and Lloyds Bank in Corn Street is covered with his work. (see page 78)

In this commission we have one sculptor making a statue to commemorate another. John Flaxman (1755-1826) worked for Wedgwood after he left the Royal Academy Schools and became very successful. He produced a vast number of monuments and he was made the first Professor of Sculpture at the Royal Academy in 1810. On his death his pupil, the Bristol-born E.H. Baily (see pages 76-77) completed his unfinished works. Flaxman is standing beside a model of a major work of the last years of his life made for Lord Egremont – a marble group, *Satan overcome by St Michael* (1822). This work is still at Petworth House, West Sussex. On the pedestal is a profile of Michelangelo.

Sir Joshua Reynolds (1723-92) was born in Plympton, Devon. He gained a great reputation as a portrait painter and as a teacher. When the Royal Academy was founded in London in 1768 he became its first President and he was knighted in the following year. In his statue Reynolds holds a copy of the *Discourses* he wrote after two years of study in Rome in his late twenties. On the broken column beside him is a relief portrait of Leonardo da Vinci. □

On the right are the complete statues in their niches prior to restoration work and on the facing page the work is shown in progress at the end of 2001.

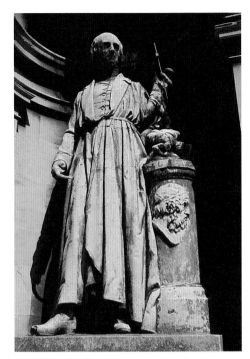

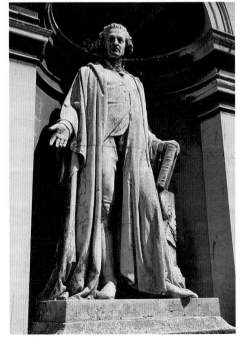

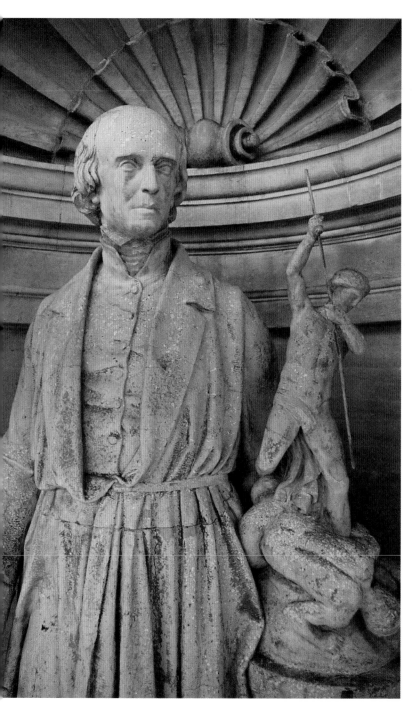

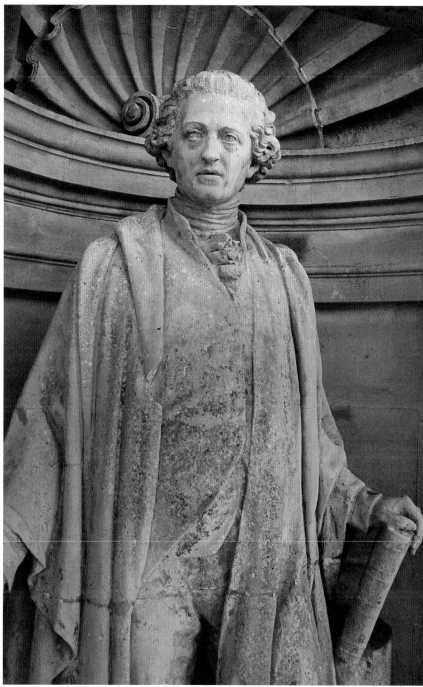

John Flaxman was an English sculptor with a European reputation

Sir Joshua Reynolds became the first President of the Royal Academy

23

5
Samuel Morley

James Havard Thomas

City centre, now on a traffic island between
Lewins Mead and Rupert Street
Erected outside St Nicholas Church in 1887
White marble
Owner: Bristol City Council
Listed Grade II

Samuel Morley (1809-1886) was clearly held in great affection by the people of Bristol and the inscription on the pedestal says over 5,000 Bristolians wished to preserve his memory 'for their children'. They did far better than that. Over a century later the statue they erected, only 14 months after his death, is still here to remind us of this now little-known politician and philanthropist.

Morley was a native of Nottingham, a staunch Congregationalist and an industrialist who became a millionaire through the hosiery business, before becoming Liberal MP for Bristol (1868-1885). His philanthropy was on the grand scale. He gave away £20,000 a year over a long period (consider this in current money values) to help the poor and to aid religious and temperance causes. He provided the evangelist and philanthropist Emma Cons (1838-1912) with funds. She 'cleaned-up' the Royal Victoria Music Hall that later became London's Old Vic. William Gladstone offered Morley a peerage but he declined.

William Henry Wills, who supported Morley as a parliamentary candidate, also favoured the

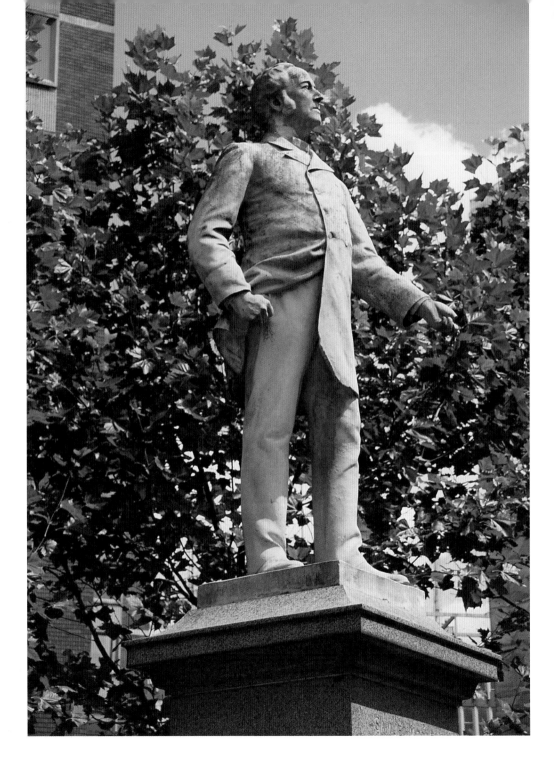

6
Queen Victoria

Sir Joseph Edgar Boehm

*City centre
on College Green, outside the
Marriott Royal Hotel*
Unveiled July 1888
*Architect: W. S. Paul
Contractor: William Cowlin and Sons
Statue: Carrara marble Pedestal: Portland stone
encased in bronze cast by James Moore Foundry,
Thames Ditton, Surrey
Owner: Bristol City Council
Listed Grade II*

The Morley statue on its first site, facing Bristol Bridge

Reece Winstone Archive

Bristol-born Havard Thomas. Through Wills's influence, Havard Thomas gained the Morley commission when he was only 32.

The sculptor's maquette of this statue is in the National Portrait Gallery and his bust of W. H. Wills (Lord Winterstoke) is in the foyer of The Royal West of England Academy.

Although the Morley statue has survived it has been on four sites. First erected at the east end of St Nicholas Church, by 1921 traffic congestion meant he was moved to a roundabout at the Horsefair. In 1954 the site was changed when Broadmead was redeveloped, and in 1997 the statue was cleaned and taken to Lewins Mead.

A letter from an elderly woman, written to the *Evening Post* in 1964, gives a cameo of two Bristol public sculptures and draws attention to Morley's pose. When she was a small child, in the late 1890s, once a week her grandfather took her in a horse-and-cart past the Queen Victoria and the Morley statues. He amused her by telling her that on a full moon, on the stroke of midnight from St Nicholas Church, Samuel would hold out his hand to see if it was raining. If the weather was good he would dash to College Green to try to kiss his monarch. □

Three events were responsible for the making of hundreds of memorials and statues of Queen Victoria (1820-1901) throughout her Empire – her two Jubilees and her death.

Bristol's decision to erect a statue for her Golden Jubilee was first made by an ex-Mayor, Sir George William Edwards in December 1886. The statue was unveiled, on 25 July 1888, by Victoria's grandson Prince Albert Victor, a <u>year</u> after the Jubilee. A photograph of the ceremony shows the sculptor, Joseph Boehm, one of a few not sheltering under an umbrella on that 'summer' day.

The statue was not always popular. Plans were made to remove her in the 1950s when the level of College Green was lowered. Many alternative sites around the city were considered and the statue was exiled to Redcliffe Wharf for three years from 1951. A capsule containing Victorian coins was found when she was moved. The Council then

resolved the statue should return to College Green and a set of nine Coronation coins – the first of the reign of Queen Elizabeth II – and contemporary newspapers, were added.

The Royal family commissioned work from Boehm for Windsor, Frogmore, Osborne and London. Queen Victoria's journal has frequent references to his work. A year after the unveiling he was granted a baronetcy. Sir Edgar

Sir Joseph Boehm, in a bowler-hat, watches the unveiling ceremony from the side of the pedestal.

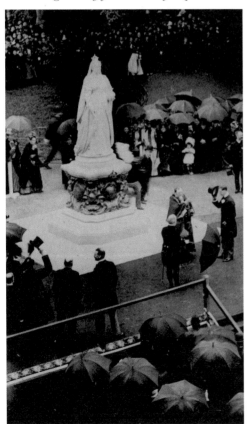

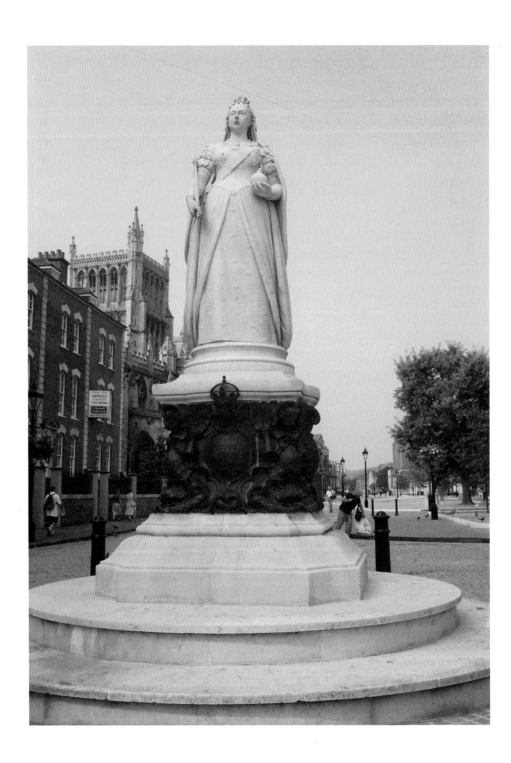

Reece Winstone Archive

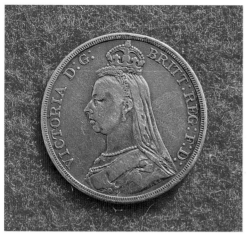

(Left) One of the coins designed by the sculptor Sir Edgar Joseph Boehm for Queen Victoria's Golden Jubilee and (below) the elaborate bronze pedestal he designed for the statue.

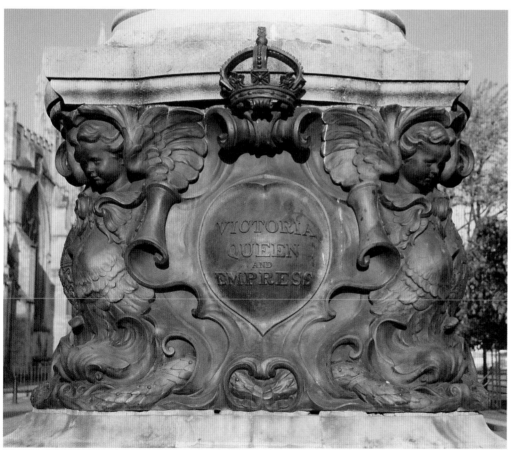

was respected in his profession but there was jealousy about his Court connections. Victorians carried Boehm's work around with them – he had designed the Jubilee coinage.

The statue was carved from a single block of white marble and the Portland stone pedestal is encased in a bronze casting of scrolls and cherubs.

Vandals removed the orb, the sceptre and damaged the hands of the statue in the late 1990s. This was not the first time. *The Bristol Times and Mirror* reported in November 1888 that 'a dozen hobbledehoys' damaged the orb by throwing stones.

There are other sculptures of Queen Victoria in Bristol. Two reliefs on the Pharmacy Arch in Victoria Square (1847), a drinking fountain in St Nicholas Street (1859), a statue on the Assize Courts in Broad Street (1870) and a figure on the George and Railway Hotel (c.1860) in Victoria Street.

Victoria had few associations with Bristol. In her childhood she stayed briefly, with her mother, in Clifton. Afterwards she came to the city only once, aged 80, during her Jubilee celebrations in 1899. □

7
Edmund Burke

James Havard Thomas

The chromo-lithographed postcard, dated 1909, shows the statue of Bristol's most illustrious Member of Parliament in its original setting.

Far right: Burke's identical twin, as he appears in Washington DC. The Bristol bronze was taken temporarily to Cheltenham in 1922 where a copy was cast by H. H. Martyn and Company.

City centre
Colston Avenue
Cast and unveiled in 1894
Bronze, cast at the Sommer Foundry, Naples
Owner: Bristol City Council
Listed Grade II

Although clearly inscribed by the sculptor, 'Havard Thomas', most references say the work was cast from the marble statue of Edmund Burke made by William Theed the Younger in 1858. The two statues are nothing like each other.

The error came from a book published to celebrate the 50th anniversary of *The Western Daily Press* in 1908. Mistakenly, that said the statue of Burke, unveiled by Lord Rosebery the Liberal Prime Minister, was 'a replica of one in the Houses of Parliament'. The newspaper printed a correction explaining that Sir William Henry Wills had offered a copy of Theed's statue as a gift to 'his fellow citizens' in Bristol in 1892 but he later commissioned Havard Thomas, a sculptor he admired, to make this original work.

Colston Avenue, Bristol.

On the Aberdeen granite pedestal are the dates '1774-1780' – not Burke's life span but the period he served as Bristol's most prestigious MP. Burke (1729-1797) was always noted for his eloquence as an orator.

He was very rarely in the city. Towards the end of his first term, realising Bristol would not accept his support of Irish trade and Catholic emancipation he withdrew from the election knowing he would not be successful.

Currently Burke is highly regarded and as one of the great political thinkers his long-term reputation is assured.

Why was Burke's statue raised in the mid-1890s? He was broadly considered a 'liberal' and the Liberal Party had many powerful

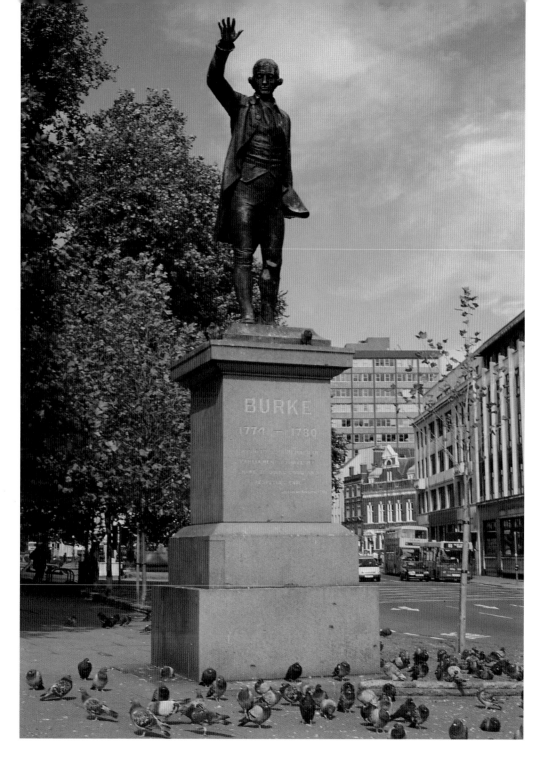

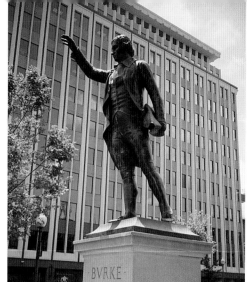

supporters in Bristol at the end of the nineteenth century. There were also growing sentiments of goodwill between Britain and the United States around that time and Burke had supported the American Revolutionists.
The Cabot Tower, built 1897, was to celebrate the 400th anniversary of Cabot's voyages and also to express friendship and peace with America.

There is a replica of Havard Thomas's Bristol statue in Washington DC. Cast in Cheltenham it went to the USA in 1922.

A 75cm-high bronze maquette of the sculptor's model was auctioned in Bristol in 1977 and a private collector in Clifton now owns this.

Sir George Clausen, RA, a student at the Royal College of Art with Havard Thomas, wrote: 'I remember him bringing an atmosphere of the 18th century classicists into the school; he would quote Burke on the sublime and the beautiful . . .' * □

* Burke's treatise *A Philosophical Enquiry into the Origin of Our Ideas of the Sublime and the Beautiful* was published in 1757.

8
Edward Colston

John Cassidy

City Centre
On an island site in Colston Avenue
Unveiled November 1895
Bronze statue and relief panels
Hoptonwood stone pedestal
Owner: Bristol City Council
Listed Grade II

Within an eight-year span Bristol acquired her
four major public statues of the Victorian era.
Morley (1887), Queen Victoria (1888),
Edmund Burke (1894) and then Colston.

Colston lived from 1636 to 1721. There is
now some distaste for the way he is thought to
have made his fortune. *A Handbook to Bristol
and Clifton* published in 1872, long before the
statue was considered, contained a frank
quotation from Garrard's *Life of Colston*. 'His
[Colston's] antipathy to dissent, it must be
acknowledged, approaches the confines of
bigotry'. Perhaps this open criticism shows
Colston was not so revered. J. W. Arrowsmith,
head of a large Bristol printing company, found
difficulty in raising funds when he announced

his idea in 1893 to erect a statue to this son and benefactor of the city.

Enough money was eventually subscribed and no fewer than 23 sculptors presented models. John Cassidy of Manchester won this competition and the bronze was cast from his plaster model by the Coalbrookdale Company.

When Bristol decided to set up a memorial statue to King Edward VII in 1911 early rumours reached Cassidy. He wrote to the committee long before the competition was announced informing them he wished to be considered and reminded them of his Colston statue, made 15 years previously. He submitted a model but he did not win. (See page 36)

Cassidy's reference may have been the portrait, painted when Colston was 66, commissioned by Bristol Corporation in 1702. This hunched, brooding, figure is in stark contrast to Rysbrack's animated marble figure of the philanthropist on the memorial in All Saints Church (1721).

Four Art Nouveau-style bas-relief plaques decorate the pedestal. Three have scenes relating to Colston's life. In one he is giving money in the street, another has mythical figures in a storm at sea and the third has the legend that one of his ships was saved when a dolphin plugged a hole in its side. He used the dolphin as a personal emblem. The remaining plaque says Bristolians proclaim him 'one of the most virtuous and wise sons of their city'.

In Armoury Square, off Stapleton Road, there is another, more modest sculptural memorial to Colston – a bust on the front of a pair of Victorian villas.

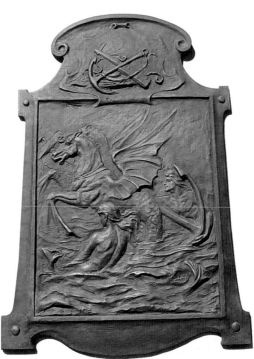

Cassidy's relief panels on the pedestal are very early examples of the Art Nouveau style in England

31

9
St George

Alfred Drury RA

Clifton College
South side of the Quadrangle overlooking the Close
Cast in 1904
Bronze statue, Portland stone pedestal
and four bronze panels
Owner: Old Cliftonians' Society
*Listed Grade II**

A panoramic view of the unveiling in 1905. The sculptor is to the far right.

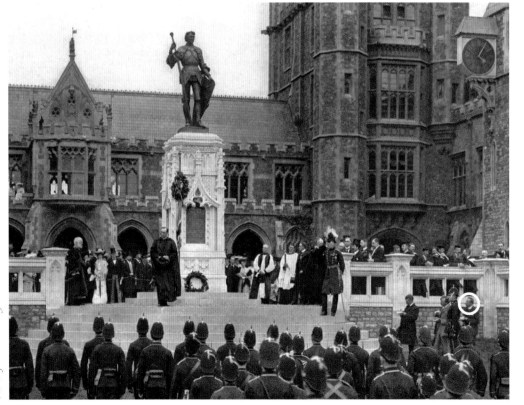

English Heritage describe this memorial as 'A very fine example . . . of the patriotic and chivalric spirit of the nineteenth-century public school movement'.

Forty-three members of Clifton College who died in the South African War (1899-1902) are commemorated. The form the memorial was to take was decided upon at a meeting held in May 1901.

Designs from architects, all Old Cliftonians, were sent to the Royal Institute of British Architects for adjudication. The winning design was by two Bristol architects, W. S. Paul* and R. C. James and it was their suggestion that

Alfred Drury, then an ARA, was approached to make the figure. Soldier or saint? The Old Cliftonians' Committee was divided. Drury submitted two sketch models – a soldier in khaki and an armoured saint – for decision. A bare majority voted for a figure of the saint and notes by Drury described it as follows: 'The armour is of the period of the late fifteenth century; the shield is Gothic with a cross of St George; the handle of the sword is surmounted by a figure emblematic of Love; the figure of Christ is surmounted by a figure of the Holy Ghost . . . the hilt takes the form of an anchor, representing the anchor of Hope. In the head of St George I have tried to express his character of Fortitude and Virtue without effeminacy'.

The Singer Foundry at Frome in Somerset cast the massive bronze, nearly 2.5 metres high.

Why was Drury chosen? In 1898 he had been commissioned by an Old Cliftonian, Henry Metcalf Gibbs, to sculpt twelve female heads for the garden of his house at Barrow Court, four miles south west of Bristol, and the memorial's architects who proposed Drury are certain to have heard of this large local project.

Sir Henry Newbolt (1862-1938), another Old Cliftonian, composed the dedication. 'Clifton, Remember these, thy Sons who fell, fighting far over sea, For they in a dark hour, remembered well their warfare learned of thee.'

Chivalry, as idealised in the statue, had played an important part in the school's code since John Percival came from Rugby to be Clifton's first headmaster in 1862 when he was only 27. There is a marble bust of Dr. Percival

* W. S. Paul designed the original setting for the Queen Victoria statue on College Green.

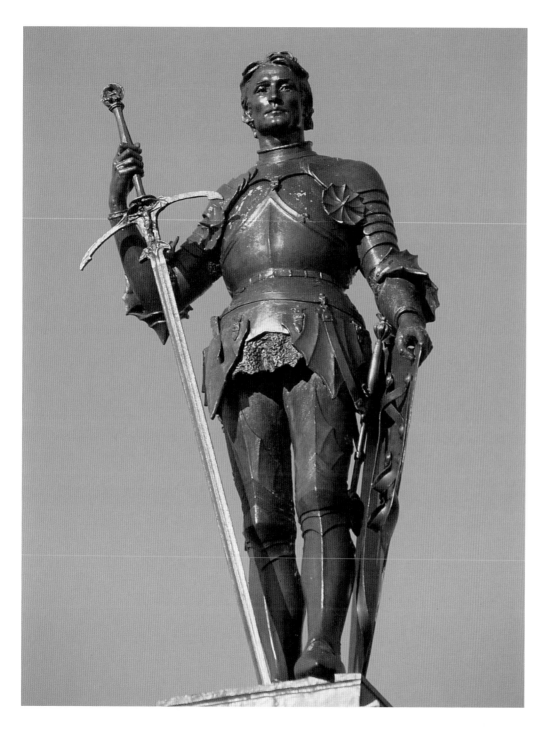

(1880) by Thomas Woolner, RA in the College.

When Lord Methuen unveiled the memorial in June 1905 he referred to 'Colonel Haig', another ex-pupil of the school. Haig's statue would later be set up very close to St George, as would the Memorial Gateway to the First World War with far more than the names here. Lack of space made it necessary to carve the names in horizontal lines – not in columns. Charles Holden designed the gateway opened by Haig with a golden key in 1922.

Methuen also asked for those attending public schools to join their volunteer corps. Millions of lives, he said, would be thrown away when war broke out unless they set to work day-by-day to make their system of defence perfect. □

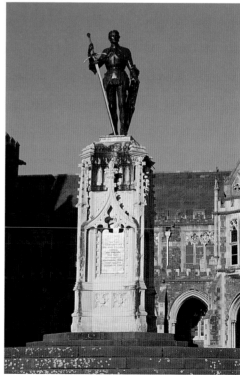

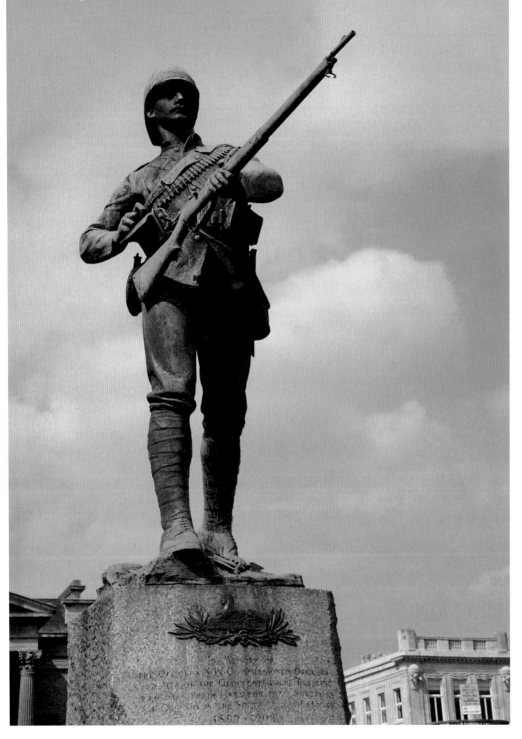

10
The Gloucestershire Regiment

Onslow Whiting

Clifton
Queen's Road
on a traffic island
in front of the Victoria Rooms
Cast 1904, unveiled 1905
Bronze statue on granite pedestal
Owner: Bristol City Council
Listed Grade II

All ranks of seven battalions contributed to this memorial to around 260 men of their regiment who died in the South African Campaign (1899-1902). Bristol was the regiment's headquarters and about 70 of the dead came from the city.

Earl Roberts, one of the Commanders-in-Chief during the Boer War, unveiled this image of a private in action, three months before the St George memorial was unveiled. (see pages 32-33) Onslow Whiting's sketch model was exhibited at the Royal Academy in 1905. The rough-hewn pedestal appears to be modern but it is part of the original design.

The soldier is taking a cartridge from his pouch to load and the figure has been criticised as 'on the wrong foot'. The pose is correct.

James McIlroy, the son of a Bristol Councillor, Isaac McIlroy (c1846-1921), is said to have been the model for the statue.

The prime organiser of the memorial was Major A. G. Lovett, 2nd Gloucestershire

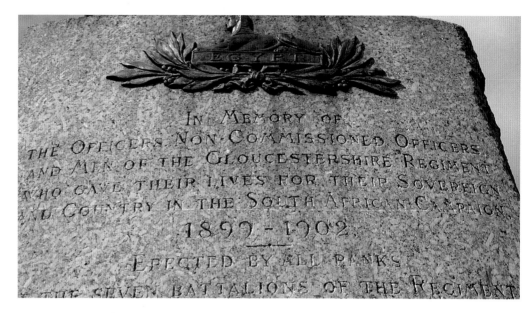

Regiment. In 1902, he wrote asking the regiment for subscriptions: 'The services of Mr. Onslow Whiting, an eminent Sculptor, whose work is frequently exhibited at the Royal Academy have been secured, and he estimates the work to cost about £500'. Lovett also reported that the Bristol City Council had offered 'a very good site on Blackboy Hill'.

The Victoria Rooms site was granted to the regiment but barely six years after the statue arrived the Major was offended to hear a rumour it might be removed. The King Edward VII Memorial Committee had not told the Gloucesters their statue would obscure the statue of the King. Lovett wrote in October 1911 to the Bristol City Engineer, a man who was probably sympathetic, Colonel Yabbicom, and reminded him they had 'worked for months to collect funds to see the completion of the Memorial'. Onslow Whiting warned that the first block of granite had split before it reached Bristol. The utmost care would be needed if anything were to be moved. After Lord Roberts' stirring speech at the unveiling the Council had undertaken to take care of the statue. Now it was asking for it to be removed.

At this point a proposal that it should go to Blackboy Hill horrified the Major.

Compromise prevailed. The road layout was changed. The infantryman advanced a mere 25 metres south-east, to his present site, at a cost of £70. By that time Major Lovett had been promoted to Lt. Colonel. □

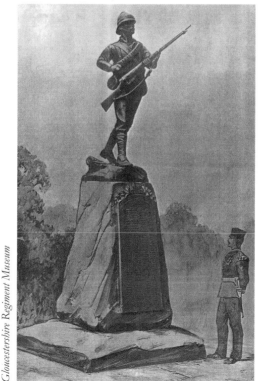

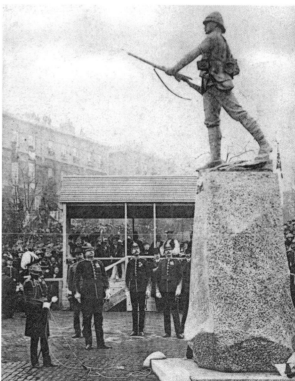

11
King Edward VII Memorial

Henry Poole

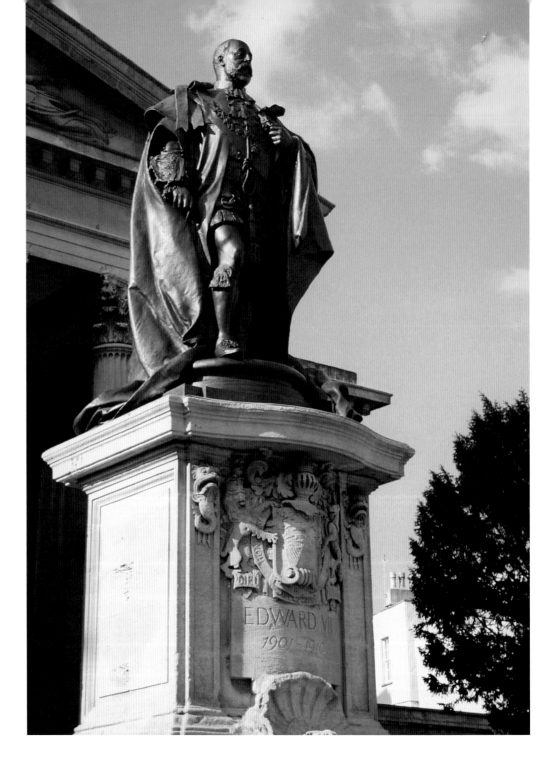

Clifton
Queen's Road
in front of the Victoria Rooms
Planned and constructed 1911 to 1917
Bronze statue, fountain and lions
Owner: Bristol City Council
Listed Grade II*

Within weeks of Edward VII's death in May 1910 the Lord Mayor of Bristol held a meeting of 'Leading Citizens' to raise funds for an *equestrian* statue of the King. The architect appointed was the London-based Edwin Arthur Rickards. He advised the Memorial Committee that the new King, George V, wished his father, 'Edward the Peacemaker', to be portrayed in a less military way.

Henry Poole won the 'limited competition' for the statue – *limited* to inviting over 30 of the best-known sculptors of the period! Twenty agreed to submit a one-eighth-scale model, without a fee or expenses. Poole's prize was £1,200 to include the cost of casting the 2.6-metre statue. The statue was cast nearby at the foundry of Singer and Company, Frome.

Poole impressed the Bristol committee so much they agreed he should also design and

The Edward VII memorial statue, fountain, lions, lamps and flagpoles transformed the space in front of the Victoria Rooms.

make the fountain. This has been praised as one of Bristol's artistic treasures and, after Rysbrack's William III, the city's next finest sculptural setting.

Plans were made for two additional groups of figures for either end of the Victoria Rooms steps and Poole modelled a whole group to full size. One was to represent 'John Cabot and the Merchant Venturers', the other 'Bristol Industries'. These groups were never realised. Ensuring that the fountain would be ready for the visit of King George V on 4 July 1913

became desperately difficult. Alexander Parlanti and Company, a foundry in Fulham, cast the 24 sections but they could not deliver on time. Part of the fountain was a painted plaster cast made hurriedly by Poole. On the day the King only saw the memorial from a considerable distance from his open carriage.

In his address the King said, 'I have viewed with admiration the fine statue of my father which you have erected . . . and I appreciate deeply the affection for his memory which the statue represents.' *Continued*

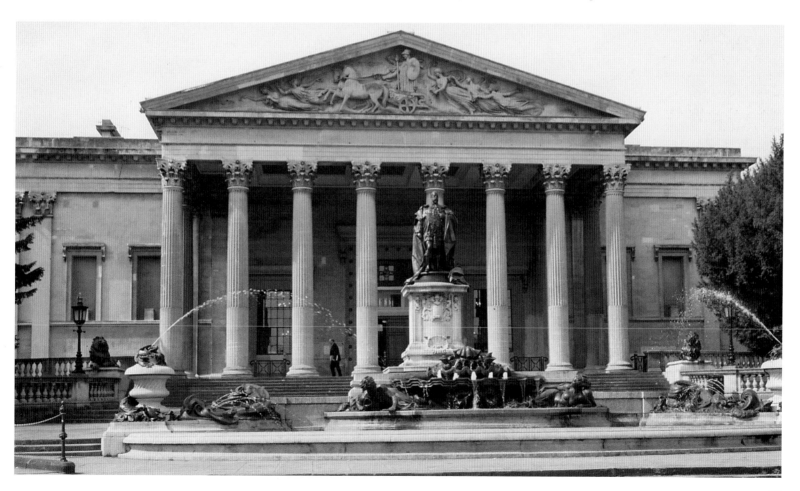

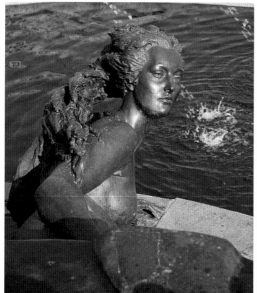

Two bronze lions were commissioned in place of the groups. Poole sent Plasticine* models to Bristol in December 1913. His estimate of £830 included granite bases. If he hoped to recoup losses made on the first stage he did not succeed. His lions were approved and cast but languished for four years, unpaid for, at Singer's foundry. That became a munitions factory and the beasts took up space required for the war effort. Cheques were finally signed and the lions arrived in April 1917. □

* William Harbutt of Bath had invented and patented Plasticine in 1897.

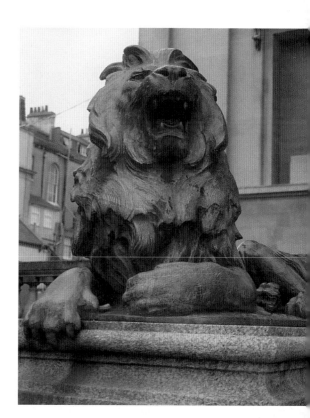

12
Emma Saunders

Ernest E. Faithfull

Temple Meads Station
on the wall, to the left of the main entrance
1928
White marble plaque
Owner: Railtrack Great Western
Listed Grade I, as part of Temple Meads Station

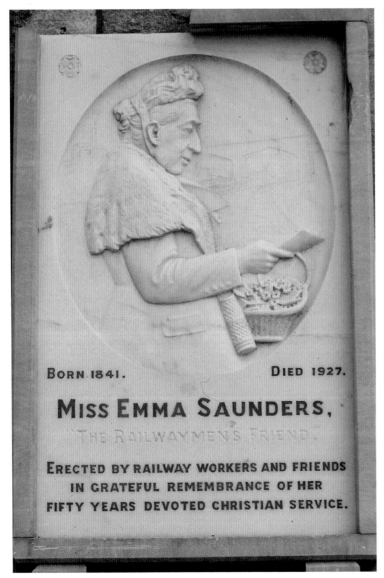

This bas-relief is typical of many twentieth-century headstones. Not surprisingly the sculptor was described as the 'Principal' of the monumental masons, H. Tyley, of Victoria Street, at the time of the commission. For generations, graves in Bristol cemeteries bore this name. Their stone yard was at St Augustine's Back and James Havard Thomas, the sculptor of the statues of *Samuel Morley* and *Edmund Burke*, said he learnt the art of marble carving from a Thomas Tyley in the 1870s. A member of the family may have carved, but not designed, the huge relief in the pediment of the Victoria Rooms. (see page 74)

A Divisional Superintendent of the Great Western Railway, H. R. Griffiths, unveiled the memorial on Sunday 1 July 1928 after a service of dedication where the GWR Locomotive Male Voice Choir had sung.

By happy coincidence, for someone whose devotion earned her the soubriquet 'The Railwaymen's Friend', Emma Saunders had been born in 1841, the year the first train arrived at Temple Meads. She came to Bristol, aged six, when her father was appointed Agent of the Bank of England in Bristol.

Aware of the harshness of railwaymen's lives she devoted more than fifty years to help them. In 1910 she set up a temperance centre with a canteen, a billiard room and classrooms. She visited the sick and even broke the news of fatal accidents to families. Regardless of bad weather she distributed flowers – her favourites were daffodils – and religious tracts.

She died at her home, 6 Sion Hill, in February 1927. Her funeral service at Christ Church, Clifton, took place on her eighty-sixth birthday – 2 March. For many years Bristol railwaymen wore daffodils when an annual service of remembrance was held for her. □

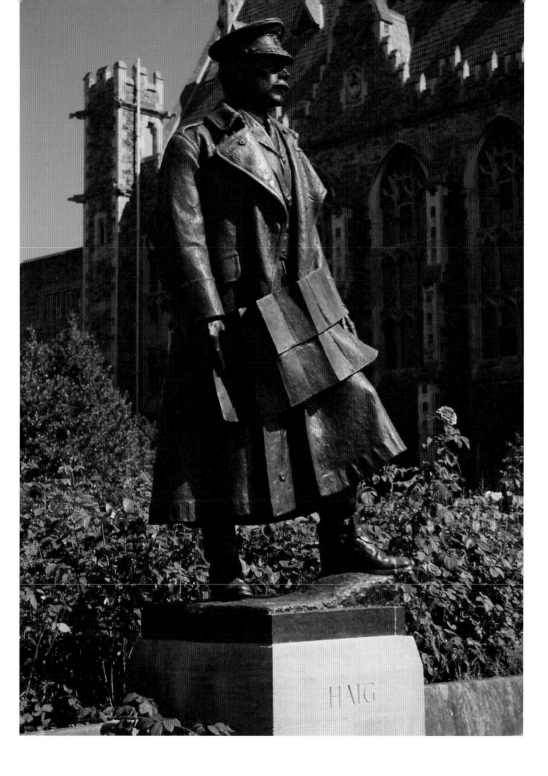

13
Earl Haig

William McMillan RA

Clifton College
in the School House garden, over-looking the Close
Cast in 1931
Bronze
Owner: Old Cliftonians' Society
Listed Grade II

Haig (1861-1928) is in battle-dress rather than his full dress uniform of field-marshal. In a relaxed pose he is unfolding a map and looking ahead as if at enemy positions on the Western Front. The pedestal merely bears his surname.

The Earl had died in January 1928. His daughter, Lady Alexandra Haig, unveiled the statue on 26 July 1932. The belated cenotaph to Bristol's war dead was unveiled on the same day. In an address the Bishop of Coventry said Haig had carried the burden of the Great War more than any other single Englishman had. He was, to be accurate, a Scot.

A Clifton College history says there had been debate 'as to what should be the proper memorial . . . but in the end it was decided to erect his statue in the School House Garden'. Haig had been in School House.

The sculptor William McMillan exhibited a model of his design at the Royal Academy in 1932. The A. B. Burton foundry cast the figure at Thames Ditton.

After Clifton, Douglas Haig was at Brasenose College, Oxford, later graduating from the Royal Military College, Sandhurst.

14
John Wesley

Arthur George Walker

Broadmead, in the courtyard of the Wesleyan Chapel known as the New Room
Cast in 1932 by A.B. Burton at Thames Ditton
Bronze equestrian statue on a limestone pedestal
Owner: The British Methodist Conference
Listed Grade II

Between 1906 and 1909 he was director of military training, forming the Territorial Army and creating an expeditionary force for a possible future war in Europe. Throughout most of the First World War he was the Commander-in-Chief of the British forces in France and Belgium.

Controversy over Haig's role in the terrible war still rumbles on. Neither army gained much ground in years of massive casualties spent with little gain to either side. Finally Haig's third Ypres offensive severely weakened the German army and in 1918 he led the British Expeditionary Force to the action that culminated in the Armistice.

Only four years ago the *Express* newspaper was campaigning for the removal of the equestrian statue of Haig in Whitehall. Its sculptor, A. F. Hardiman, RA, was commissioned to make the Unicorns for the Bristol Council House but the Second World War delayed construction and he died in 1949.

Haig helped to create the British Legion and travelled throughout the British Empire as its President to raise funds for ex-servicemen. From this work came 'Poppy Day'. □

John Wesley had been described as 'a donnish Anglican clergyman'. When he arrived in Bristol, on 31 March 1739, he had misgivings about preaching in the open-air but only two days later he went to the brick-fields in St Philip's Marsh and addressed a crowd of about 3,000 people.

Bristol immediately became important to him. He purchased land in Broadmead and laid the foundation stone of The New Room, the oldest Methodist building in the world, by Saturday 12 May 1739.

Remarkably the chapel has survived for over

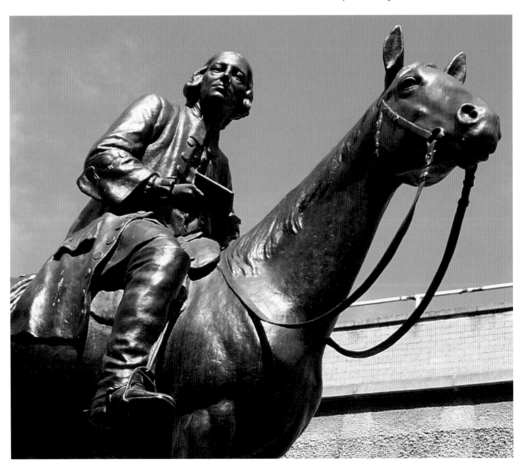

260 years among shops that huddle in on all sides and where buildings were destroyed in Second World War bombing. After Wesley's death the building was sold in 1808 to Welsh Calvinist Methodists. They used it until 1929 when Edmund Sykes Lamplough (1860-1940), a wealthy Methodist and Deputy Chairman of Lloyd's of London, bought it back and presented it to the Wesleyan Methodist Conference. He paid for all the restoration and asked the doyen of Bristol architects, Sir George Oatley, to undertake that work.

In October 1930 Sir George suggested that a statue of John Wesley would enhance the scheme, recommending A. G. Walker as the sculptor. Although Lamplough immediately liked the idea over a year passed before the subject and style of the sculpture were decided. Would it be better to have an equestrian statue of Francis Asbury, the apostle of American Methodism, who left Bristol in 1771 or should it be a standing statue of John Wesley?

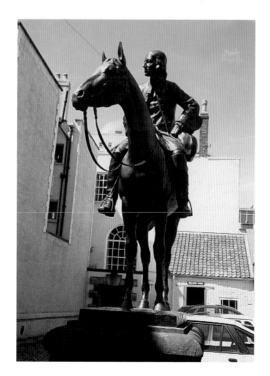

That would have only cost £1,250. Or should it be an equestrian statue of John Wesley? Walker estimated that at £2,500. Lamplough was 'staggered' at that sum. At first he thought it reasonable for a statue in London but not in Bristol. Walker must have been persuasive. After a meeting with him in his Chelsea studio, Lamplough gave him the commission.

Wesley and his horse are inseparable in Methodist folklore. In the course of a quarter of a century he rode an estimated 250,000 miles. Wesley is shown using a slack rein as he habitually read while riding and needed to give his horse 'a certain liberty'. His stable is preserved in the corner of the courtyard. On the opposite side of the building is a statue of his brother, Charles. (see page 45)

John Wesley (1703-91) was born at Epworth, Lincolnshire and died in London. His father, a clergyman, sent both sons to London for their early education. John attended Charterhouse, then entered Christ Church, Oxford in 1720 and was ordained in 1728. He was already in Oxford when Charles went there and, after he experienced a 'spiritual awakening', they gathered like-minded students to study the Bible and pray. Their activities among the poor and in prisons made them conspicuous and earned them various derisive nicknames – one of them 'Methodists'.

John became leader of the group that grew into a powerful worldwide movement. □

15
Abigail Chute

Eric Gill

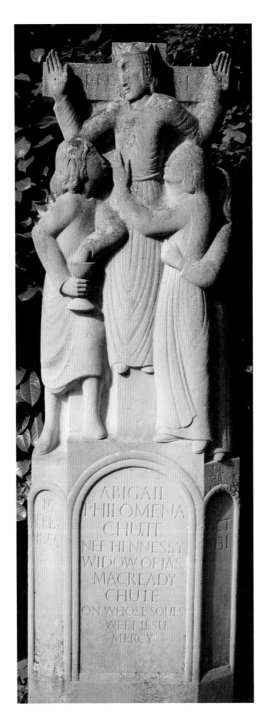

Canford Cemetery
Westbury on Trym
1932-33
White marble headstones
Owner: Trustees of the Chute Family

Abigail Chute was the matriarchal figure of a family of actors and managers who guided the theatrical world of Bristol for generations.

She was the daughter-in-law of James Henry Chute who built the Prince's Theatre in Park Row in 1867 and leased both the Theatre Royal in King Street and the Theatre Royal in Bath. When her husband died she managed the Prince's Theatre and is said to have 'dominated it with great determination'.

Mrs Chute was a Roman Catholic and the sculptor Eric Gill was a close friend of her son, Desmond. Through that relationship, Gill, one of the most influential English sculptors of the first half of the twentieth century, has left us sculpture hidden in a public cemetery and, as always, Gill's lettering is of exceptional quality. Three headstones, all in the same style, record her death and other members of the family.

German bombing in November 1940 destroyed the Prince's Theatre, Abigail's heritage. A leading theatre architect, C. J. Phipps, had designed the building. Now it is difficult to realise that the site of one of the biggest theatres ever built in the provinces (around 1,500 seats) lies beneath an apartment block and a petrol filling station.

A single pilaster from the Victorian façade remains on a shop in Park Row but one Bristol commentator complained that the theatre, so important to the Chute family, should have no memorial beyond its fame. He was pleased the theatre avoided the ignominy of becoming a bingo hall, had it survived.

Gill had a link with Bristol through the bookshop proprietor Douglas Cleverdon. He painted the fascia above Cleverdon's shop* at 18 Charlotte Street in his sans serif lettering.

The nave of Cotham Parish Church has a carving by Eric Gill, called *The Good Shepherd* (1925), dedicated to the memory of the Reverend Henry Thomas who was pastor of that church for 47 years. □

* Also destroyed by a Second World War bomb.

44

16
Charles Wesley

Frederick Brook Hitch

The Horsefair, Broadmead,
in the rear courtyard of the New Room
Cast in 1938
Bronze, on a Hornton stone pedestal
Owner: The British Methodist Conference
Listed Grade II

Charles Wesley's statue in Bristol was the first to be erected to him. It was unveiled to coincide with the two-hundredth anniversary of the opening of the chapel. Some years later the *Bristol Evening Post* said, 'The statue of Charles . . . was an important step towards the perfection of this Methodist shrine visited by adherents of the faith from all over the world.'

The donor was Sir Arthur M. Sutherland of Newcastle-on-Tyne. His daughter unveiled the statue on 3 June 1939 and on the following evening the service in the New Room was

broadcast by the BBC. It was not until 1954 that the layout of a garden for the present setting for the statue was achieved.

Charles was born at Epworth in Lincolnshire on 18 December 1707 and he died on 29 March 1788 in London. He was one of the outstanding hymn writers of all time. The *Encyclopaedia Britannica* credits him with a staggering total of 'over 4,500 published hymns and some 3,000 in manuscript'. He wrote many when he was walking or riding on the Downs, or travelling to preaching engagements.

When he brought his 21-year-old bride, Sarah Gwynne, to Bristol he was 42 and they lived in various houses in the Charles Street area. From 1766 to 1771 they were at No.4. They had eight children. A gravestone now in St James's Park records five had died in infancy by the time they moved to London in 1771.

The Rev Dr Ferrier Hulme, who was Chairman of the Wesleyan Methodist District in Bristol and President of the Wesleyan Methodist Conference at that time, chose Frederick Brook Hitch for this commission. Brook Hitch based Charles Wesley's likeness on portraits made during his lifetime and his sketch statuette was exhibited in the New Room in February 1938. Some minor alterations were suggested before a full-size model was made. The statue cost £709.16.6 and the pedestal and foundations £60.11.3.

Some aspects of Wesley's life are given on page 43, where the statue of his brother is presented. They share a sculptured memorial in Westminster Abbey and there is a plaster cast of this in the New Room.

Edward S. Lamplough, donor of the John Wesley statue, purchased the Charles Street house in 1931. In the 1990s the house became an international Charles Wesley Centre. □

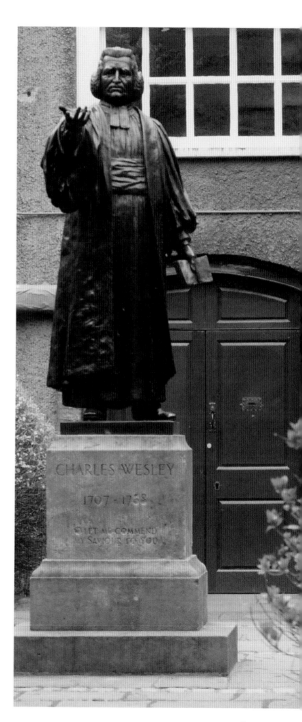

17
Charles Holden

Paul Vincze

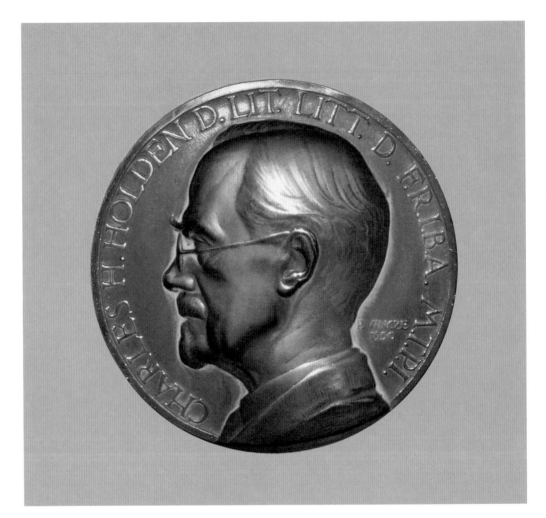

City centre Deanery Road, College Green,
inside Bristol Central Library, on the first floor
1950
Circular bronze medallion
Owner: Bristol City Council
Listed Grade I

Almost half a century after Holden had won
the architectural competition to design Bristol's
public library in 1902 this small tribute to him
was set up. But it was in place ten years before
he died. The surface of the medallion is now
rather worn, due to frequent cleaning.

Charles Henry Holden (1875-1960) is
considered to be one of the great British
architects of the twentieth century and he
integrated sculpture in much of his work.
When he designed the headquarters of the
British Medical Association in the Strand
(1907) he used Jacob Epstein. For his
headquarters of London Transport in
Broadway, Westminster (1927-9), he
commissioned Epstein again. Eric Gill and
Henry Moore were also employed for the bas-
reliefs on the central block.

The library is one of Holden's most
remarkable works. Charles Rennie
Mackintosh's winning design for the
competition for Glasgow School of Art in 1896
is said to have influenced Holden in this early
commission. Another influence on Holden was
C. R. Ashbee, a leading Arts and Crafts

designer with whom Holden had worked.

A few years later Holden and his partner
H. Percy Adams won the commission for the
Bristol Royal Infirmary (1906-11).

He became an early exponent of the
Bauhaus style in Britain, applying this to at
least 18 of the London Underground stations
in Middlesex from 1932 onwards.

Holden, a Quaker, was born in Bolton, one
of six children, and his mother died leaving
him to be brought up by a sister.

His father had failed in business. In spite of
these circumstances he succeeded in building
up one of the largest practices of his
generation. He declined a knighthood saying
this would 'alienate him from ordinary people'.

He chose the sculptor Charles Pibworth to
design and carve the three external panels on
the Bristol Central Library. (page 83)

Bristol was the second provincial city in
England to have a public library. A merchant,
Robert Redwood, endowed this in 1613. □

18
Samuel Plimsoll

Sculptor unknown

*At Hotwells, beside the Avon
at the entrance to the Cumberland Basin*
c.1880
Unveiled on present site 24 July 1962
Servezza marble, pedestal Cornish granite
Owner: Bristol City Council

Listed Grade II

Memorials of Samuel Plimsoll MP (1824-1898) appear in almost every port in the world – the marks on the hulls of ships.

On failing to pass his own parliamentary bill to prevent overloading Plimsoll wrote *Our Seamen,* published in 1873. This book pleaded that a 'maximum load line' should appear on the side of all ships and that no ship should leave port without that being visible above the waterline. His powerful case led to the passing of the Merchant Shipping Act of 1876.

There were at least two attempts to set up a memorial to Plimsoll in Bristol before 1962 but after a century of doubt and dispute there is evidence that he was born here.

In 1919 a meeting, held by Bristol's Lord

Mayor, began with much enthusiasm until someone asked, 'Was there any evidence that Plimsoll really was born in Bristol?'
The meeting adjourned for proof to be found.

A monument to Plimsoll in the Embankment Gardens, London, unveiled in 1930, prompted 'The Citizens of Bristol' to meet again. Sir George Oatley, J. A. Short, a long-term campaigner for a Plimsoll memorial, and Ferdinand Blundstone (sculptor of the London tribute) were present at the Council House on 12 March. Again, nothing was achieved beyond letters in the press arguing over Plimsoll's birthplace.

Another 32 years passed before Lord Mayor L K Stevenson, a member of a Bristol shipping family, unveiled this bust at Hotwells, to the hooting of the sand-ship *Harry Brown,* in 1962.

The bust, reputedly of Plimsoll, had been purchased in 1940 for £10 from a dealer in Stratford-upon-Avon and placed in the Bristol Art Gallery. There is no confirmation of the identity of the subject, or of the sculptor.

The Plimsoll Club of New Orleans visited Bristol in 1968 and commissioned a bronze replica from a Bristol sculptor, the late Ernest Pascoe, for their city.

In *The Plimsoll Line* (1975) George Peters established that Thomas Plimsoll, a Huguenot and employee in the Excise service, rented 3 Colston Parade, and his eighth child, Samuel, born on 10 February 1824, was baptised at Bridge Street Congregational Church. When Samuel was three the family left for Penrith.

Samuel became secretary to the 1851 Exhibition, was a coal merchant in London and by 1868 he became Liberal MP for Derby.

Bristol's history as a great port is an appropriate place to pay tribute to him, but he deserves a worthier monument. □

19
St Francis of Assisi

Judith Bluck

City centre Greyfriars, Lewins Mead
1974
Cement suspended in polyester resin
Owner: GE Capital Corporation (Investment
Properties) Limited and Opus Land Limited

There was a Franciscan monastery on the site
of the office block until the sixteenth century.
Six large exterior and three interior panels in
the entrance hall are modelled in very deep
relief; even the handles of the entrance doors
are decorated in the same mode. Judith Bluck
tells the story of St Francis as a young knight,
helping lepers, dreaming of poverty as his
bride, renouncing his possessions, taking St
Clare into his order and the story of his taming
of a wolf.

Most public sculptures would benefit from
information on site and here it is supplied.
A large marble tablet is set in the pavement
beside the reliefs. That tells us a great deal and
puts in context the legends known as the
Fioretti or 'Little Flowers of St Francis' and
explains why they are relevant to this building
in the centre of Bristol.

Francis was canonised only two years after
he died in 1228 and a mere thirty years later a
community built a friary outside the walls of
Bristol on the banks of the River Frome. □

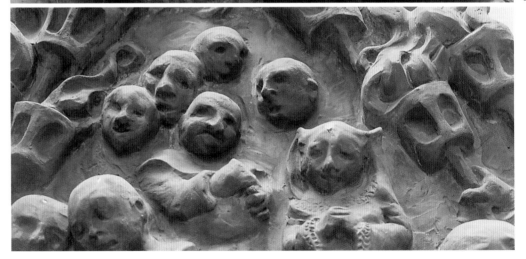

Photograph: Stephen Morris

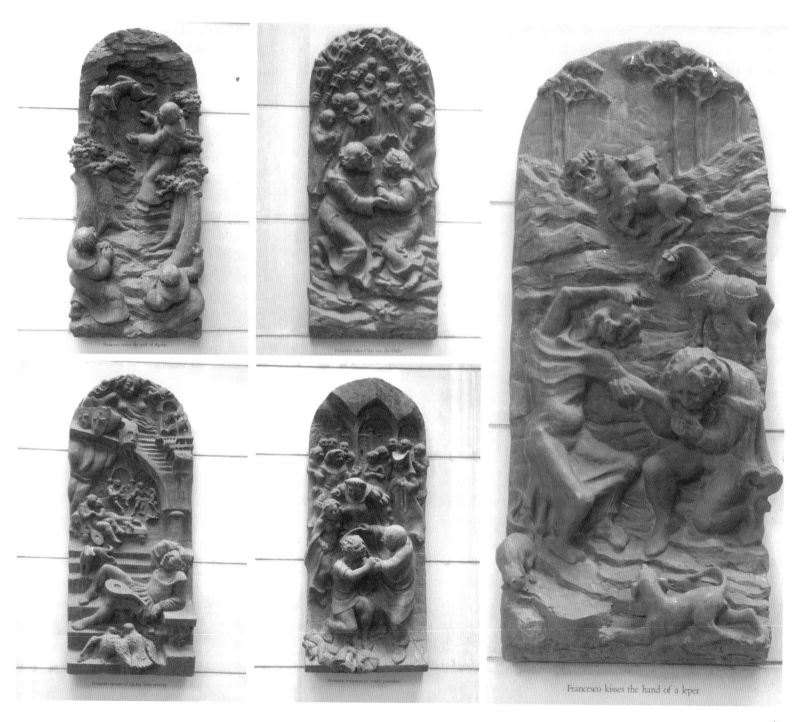

Francesco kisses the hand of a leper

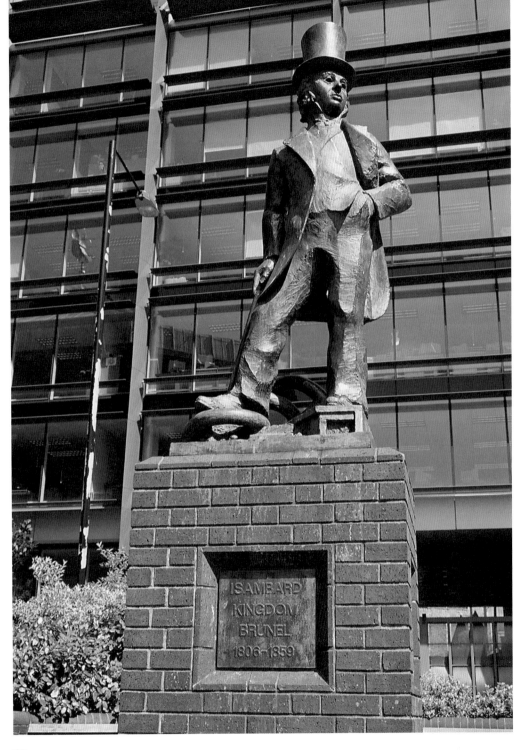

20
Brunel

John Doubleday

*City centre
in front of the former Bristol and West offices
Cast in 1982
Bronze statue made in London by the Art Bronze
Foundry on a glazed brick pedestal
Owner: Bristol City Council*

After the unveiling on 26 May 1982 a Bristol newspaper commented 'It will probably be the first time that two statues of the same person by the same sculptor will have been unveiled on the same day'.

Bristol and West had commissioned <u>two</u> statues at the time of the opening of their newly completed office extension in Bristol. They donated the Bristol version to the city. A companion statue, of Brunel seated, was made for Paddington Station. In a flourish that Brunel would have admired the Lord Mayor of Westminster and the Chairman of Bristol and West unveiled both statues within less than three hours of each other – the London statue at 10.45am. They presented the Paddington version to British Rail and travelled on an Inter City 125 to Bristol where, at 1.30pm, the Lord Mayor of Bristol unveiled the second statue.

Isambard Kingdom Brunel (1806-1859) was born in Portsmouth. His father was French. Kingdom was his mother's maiden name.

He made immense contributions to Bristol by building the Great Western Railway and

ISAMBARD
KINGDOM
BRUNEL
1806-1859

connecting the city with London in eight years. In June 1841 a decorated train left Paddington and reached Bristol in four hours.
His improvements to the Bristol Docks (1835) and, most notably, the building of the s.s. *Great Britain* (1843) were other achievements.

The Institution of Civil Engineers completed Brunel's innovative Clifton Suspension Bridge as a memorial to him. One of his biographers wrote, 'More surely than any lineaments in stone or pigment, the aspiring flight of its single splendid span has immortalised the spirit of the man who conceived it.'

Doubleday's figure is reminiscent of the much-reproduced photograph, taken by Brown Lenox and Co. Limited at Wapping (c.1857), where Brunel stands against the chains of *The Great Eastern*. Uncharacteristically the Bristol statue carries a walking stick. Doubleday's statue of Charlie Chaplin, also sponsored by Bristol and West, stands in London's Leicester Square. He has another sculpture in Bristol called *Phoenix,* standing outside what were the Royal SunAlliance offices at Redcliffe Way.

Bronze casts, approximately 20cms high, of the maquettes John Doubleday made for both his statues of Brunel have been presented by Bristol and West plc and these are now on permanent display in the Suspension Bridge Centre in Clifton. □

21
Katyń Memorial

Alexander Paul Klecki

Clifton
Worcester Road
in the precincts of Roman Catholic Cathedral
Unveiled 5 May 1985
Granite with metal cast relief
Owner: The Polish Community in Bristol

The rectangular bronze relief was designed and made by a Polish sculptor living in London. It has four very deep lines that form a crucifix. Within this space is a formalised human figure in agony. The relief is mounted on a seven-ton block of Cornish granite, chosen for its similarity to stone at Katyń, and positioned by Alexander J. Chelmicki a Bristol resident.

A committee set up by the local Polish community in Bristol was formed to erect this memorial to over 4,000 Poles massacred during the Second World War. Responsibility

for their deaths was disputed for over 40 years.

When funds were being raised the original intention was for the work to be placed outside the Polish Church in Cheltenham Road but, as often occurs in the establishing of public sculpture, negotiations altered and Bishop Alexander accepted the memorial should be on its present site at the Roman Catholic Cathedral in Clifton.

When the Second World War started in 1939 Germany attacked Poland from the west and the Soviet Union occupied the eastern half. As a result the Soviets captured ten of thousands of Polish Forces and sent them to prison camps inside Russia.

When Russia was invaded by Germany in 1941 Great Britain and the USSR became allies. General Sikorski, leader of the Polish Government in Exile, made an agreement with the Russian Ambassador in London that Polish prisoners in the USSR should become part of an amnesty. A Polish army was formed under General Anders to fight the Germans and 300,000 soldiers were assembled but it was soon apparent 15,000 officers were missing.

On 13 April 1943 the Germans uncovered over 4,000 corpses of Polish officers in the Katyń Forest, near Solmensk, claiming they had been killed by the Soviets in 1940; the Soviets blamed the Germans. Not until 1992 did the Russians reveal NKVD documents and accept the Katyń massacre.

The Bristol memorial says simply, in Polish and English: 'To the memory of those massacred in Katyń 1940'. □

22
St Odilia and the Bird

Stephen Joyce

City Centre Lower Maudlin Street
In an inner courtyard of Bristol Eye Hospital
1985
Bronze resin figure of a woman and a bird
Owner: Trustees for the United Bristol Hospitals

This sculpture, that unusually includes a flying bird, was commissioned at the same time as the large brick relief for the façade of the Eye Hospital. (see page 118)

Various dictionaries of saints give alternative spellings of her name. Otillia, Odilia, Othilia, even Adilia. One says authentic particulars about her are almost wholly lacking. Her saint's day is 13 December and most references link her to the eighth century and to Alsace. She is described as the daughter of a nobleman who rejected her because of her blindness. She became the Abbess of two nunneries she had founded at Niedermünster and Hohenburg (now Odilenburg), both of the Benedictine rule. Her shrine at Odilenburg became a place of pilgrimage for people who were blind or suffering from eye diseases.

A bronze plaque in the outpatients' waiting tells the story behind Stephen Joyce's sculpture in the following way: 'St Odilia, the patron saint of eyesight lived in the 9th century. Blind at birth she was cast out by her family and adopted by nuns. At the convent she miraculously regained her sight and later became the abbess. She saw a bird flying overhead at the moment her sight returned.' □

23
John Cabot

Stephen Joyce

City centre
at the southern end of Narrow Quay
outside the Arnolfini
Erected in 1986
Owner: Bristol City Council

Stephen Joyce's Cabot has his feet on the ground. He has no pedestal and children can climb on him. Parts of the bronze are being burnished to 'gold'.

The Bristol architect Mike Jenner called him 'a weather-beaten sailor in his timeless working clothes, seated but alert in every muscle'. He gazes westward, across the Floating Harbour – hair tied with a scarf above an open-necked shirt; his arms are crossed. Tight-fitting breeches are tucked into his boots.

Little is recorded about Cabot (Giovanni Caboto) the explorer and navigator. He may have been born in the Italian port of Genoa around 1450 but it is recorded he became a Venetian citizen in 1476. Independent of Columbus he planned to reach Asia by sailing westward. Cabot arrived in England about 1494 and Henry VII granted a charter to him and his sons on 5 March, 1496. He left Bristol in May 1497 in his small ship the *Matthew,* named after a son, and landed somewhere on the North American seaboard. He assumed

24
Alfred Fagon

David Mutasa

St Paul's
in the Ashley Road and
Grosvenor Road triangle
Made and unveiled in 1987
Bronze bust on a black marble pedestal
Owner: Friends of Fagon Committee

he had found Asia, and described the land as excellent and the climate temperate with an abundance of fish. He did not return from his second voyage to America in 1498-99.

In 1983 Avon County Community Environmental Service started a project for a statue of John Cabot. Stephen Joyce produced a clay model to interest possible sponsors. By 1987 a new environmental arts trust, Changing Places, was set up to encourage improvement of the City and this was one of their notable successes.

When the Cabot statue appeared, Reece Winstone – observer and photographer of Bristol – wrote to the *Bristol Evening Post*. 'Approaching from the Prince Street Bridge . . . I spotted what looked like the back view of a large frog . . . not our famous explorer.' Perhaps Reece Winstone would have preferred Ernest Board's skilful but theatrical painting of Cabot in Bristol City Museum and Art Gallery where the figures look as though they were appearing in a maritime musical at the Hippodrome, all tights and heraldry.

Joyce has over a dozen public sculptures in Bristol. (*St Odilia*, page 53 and *Horse and Man*, page 116). He has a bust of Isambard Kingdom Brunel in the foyer of Brunel House, St George's Road.

His is the only statue of John Cabot in Bristol. The figure outside the Council House is called 'An Elizabethan Seaman'. (page 90) □

Actor, playwright and poet Alfred Fagon (1937-86) lived in St Paul's in Bristol through the 1960s and 70s. Born in Jamaica he came to England when he was 18 and served four years in the British Army, becoming middle-weight boxing champion of the Royal Corps of Signals. He travelled around England as a singer before settling in Bristol. Amateur appearances at King's Square Arts Centre led to professional acting in television, including work with HTV, and he later established himself as a writer.

As a playwright he worked with the ICA in London, the BBC, the Royal Court and Foco Novo. His plays include *No Soldiers in St Paul's* (1974) and, ironically, *Death of a Black Man*. At the time of his death he was the only British black playwright to have had work broadcast on national television.

His death was the subject of an HTV documentary and this public memorial was unveiled on the first anniversary. In later life Alfred, an habitual jogger, lived alone in Brixton and was known to neighbours as 'the coloured man who ran'.

In August 1986 police found a man in a track-suit who had collapsed in the street.

When taken to hospital he was dead-on-arrival with no identification. His death was certified as a heart attack. Leads to his identity were not followed before he was cremated – not by name but by the number T91 although later friends in Bristol and relatives were contacted. He was a member of Equity and there were letters in his flat from his literary agent.

Several hundred attended a service at Parkway Methodist Church in November 1987. Some of those formed a Friends of Fagon Committee and established a fund to design and erect a sculptural memorial. This was done with the Council's assistance.

Two hundred were present when Fagon's sister flew from Los Angeles to unveil the memorial. Among them were Rudolf Walker, the star of the television programme *Love Thy Neighbour,* Jim Williams, Bristol's first black councillor, Councillor Joan Jones, the Deputy Lord Mayor and the sculptor, David Mutasa.

Included in the inscription on the pedestal are the words:

ALFRED FAGON

POET PLAYWRIGHT ACTOR

ERECTED ON THE FIRST ANNIVERSARY

OF HIS DEATH □

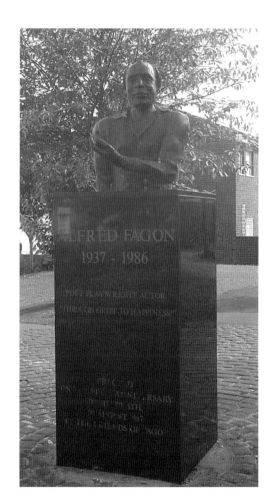

25
Arnos Court Triumphal Arch

Susan Dring

Arnos Vale Bath Road, Brislington
Modern versions of statues, 1994
Bathstone from Limpley Stoke Quarries
Listed Grade II

Bristol Development Corporation rebuilt large areas of Arnos Vale from 1990 to 1996. Mike Jenner, their architectural advisor, restored the Gothick gateway as part of that work.

William Reeve had originally built the gate in the 1760s as an entrance to the stables of his new house, Arnos Court. Two of Bristol's medieval gateways were being demolished and Reeve acquired four statues taken from them.

He was an enthusiastic collector of antiquities and placed them in niches in his gate. In 1912 this had to be moved to its present position, facing up the Bath Road, and the statues were taken to Bristol's new Museum and Art Gallery. Much later they went to the Tourist Centre in St Nicholas Church.

During the 1990s restoration it was decided that because the niches are too accessible for the safety of the ancient statues they would be filled with newly made figures.

Susan Dring was first commissioned to make clay mock-ups based on the originals. When these were approved she carved the 1.8-metre figures from stone especially quarried from a deep seam found at Limpley Stoke, south-east of Bath. They are not precise copies

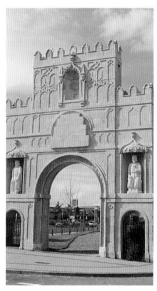

because the 600-year-old carvings were very eroded, probably cut down to fit the niches and, on at least two occasions, they had been absurdly and inaccurately 'restored'.

The two kings came from Lawford's Gate. The others, from Newgate, are possibly wrongly attributed. They are said to represent Bishop Geoffrey from Coutances, in Normandy, founder of Bristol Castle and Robert Fitzroy, Earl of Gloucester, who re-built and enlarged it.

Both Edwards were important to the city. When Edward I (1239-1307) was only fifteen his father gave him Bristol as part of a generous wedding settlement. He also received parts of France, Ireland, much of Wales and the Channel Islands. His bride, Eleanor of Castile, was eight at the time.

When she died in 1290 Edward himself became a patron of public monuments. He erected twelve Eleanor Crosses to commemorate the sites where his dead

queen's body had rested on its return to London from Nottingham.

Edward III (1312-1377) was the monarch who granted Bristol a Royal Charter conferring upon it the status of City and County in 1373 – the year a new High Cross was erected to commemorate the event.

St Nicholas Church has been closed as a Tourist Centre and the ancient original statues are to be placed in a new city museum, possibly on Prince's Wharf. □

Edward I who gave Bristol its Royal Charter.

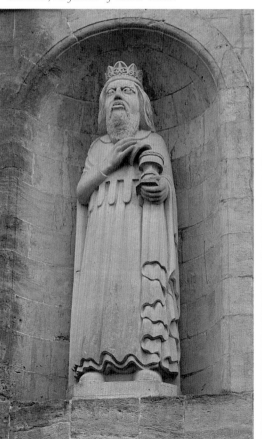

This is thought to be the Norman Bishop Geoffrey of Coutances, the founder of Bristol Castle.

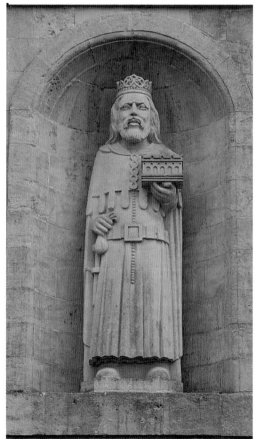

Robert Fitzroy, an illegitimate son of King Henry II, builder of St James' Priory, Bristol, where he is buried.

26
Raja Rammohun Roy

Niranjan Pradhan

City centre
College Green
1997
Bronze
Owner: Bristol City Council

Rammohun Roy (1772-1833), a humanist and religious reformer, came from India to Bristol in 1831 to meet like-minded people, mainly Unitarians, who were concerned about greater understanding between world religions. He worked for a synthesis of Eastern and Western culture, campaigned for the abolition of *suttee** and wrote in favour of the equality of women.

The Raja was a high-caste Brahmin, born in Bengal, and the first Hindu known to have visited Britain. His journey made him vulnerable to his religion's custom that those who travelled outside Hindu India should become outcast and forfeit their property. This sanction never arose as he died of meningitis while staying at Beech House, Stapleton Grove and was buried in the garden of that house. The problem of where he could be buried permanently took ten years to resolve. His coffin was then taken to Arnos Vale Cemetery where his unusual *chattri* (funeral monument), designed by William Prinsep and based on Hindu temple architecture, still stands.

Niranjan Pradhan modelled and cast the statue in his own studio in Calcutta and he was present at the unveiling. The reference for the likeness and for the costume was the large oil painting by H. Perronet Briggs in the Bristol Museum and Art Gallery. This portrait was made from life only a year before Rammohun Roy's sudden death. He travelled as an ambassador and the Persian shawl and the clothes he wore were the court dress of the Mogul Emperor Shah Alam II. There is a bust of Rammohun, made by the same sculptor in 1995, in the foyer of the Council House.

There was very heavy rain when the Indian High Commissioner, Dr Singhvi, who had helped to raise money for the memorial in India, unveiled the statue on the evening of 20 November 1997, the Golden Jubilee of the Independence of India. The statue was placed on its pedestal only 24 hours before the unveiling but fifteen years had elapsed from the first proposals for the memorial. By coincidence, heavy rain spoilt the unveiling of Queen Victoria's Jubilee statue in 1888.

The revered Indian died four years before Victoria came to the throne. Now his statue and that of the Empress of India stand only a short distance apart. □

* The Hindu custom where widows were burnt to death on their husbands' funeral pyre. It was abolished in 1829, before Rammohun Roy died.

27
William Tyndale

Laurence Holofcener

Canon's Marsh Millennium Square
2000
Bronze statue
Owner: @ *Bristol*

in their own language. In 1536 he was garrotted and burnt at Vilvorde, Belgium, for his efforts.

Tyndale had fled to Germany, aided by London merchants, when church authorities prevented him translating the Bible from Greek into English. An estimated 3,000 copies of his New Testament were printed at Cologne in 1525. Only three have survived.

One copy was held by Bristol Baptist College until a few years ago, when it was sold to the British Library for safe-keeping for a little over one million pounds. Dr. Andrew

Gifford, a Bristol Baptist, had bought it for 20 guineas in 1776 and bequeathed it to the Baptist College.

Tyndale was born in Gloucestershire. He studied at Oxford, taught at Cambridge and preached briefly in and around Bristol. There is a statue of Tyndale on the Embankment Gardens in London by Boehm, the sculptor of Bristol's Jubilee statue of Queen Victoria. A tower, dedicated to Tyndale at North Nibley where he may have been born, can be climbed and there are spectacular views. □

All three of Laurence Holofcener's figures in Bristol's new public space are in the style he used for his London sculpture, *Allies* (1995) in New Bond Street, at the junction with Grafton Street. There, without pedestals, a benign President Roosevelt and smiling Sir Winston Churchill are seated on a bench, with space for passers-by to sit between them.

In Bristol the scholarly translator, William Tyndale, smiles gently as he works on his New Testament – unaware of the consequences of his wish that Christians should read the Bible

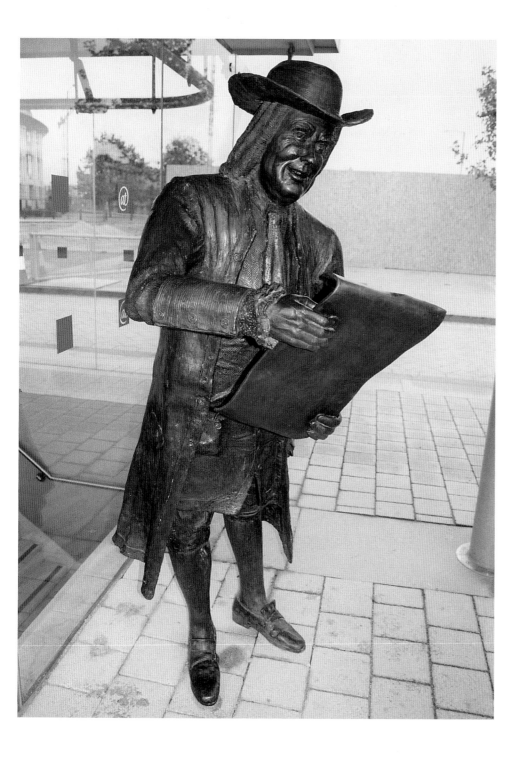

28
William Penn

Laurence Holofcener

Canon's Marsh Millennium Square
2000
Bronze statue
Owner: (at) *Bristol*

A statue of William Penn (1644-1718) joined Chatterton and Tyndale in Millennium Square as an 'Eminent Bristolian' (as the plaque in the pavement describes him) at the beginning of 2000. He is certainly eminent and, not being on a pedestal, very approachable but the claim that he was a Bristolian is dubious.

Visitors from the United States will salute him. He oversaw the founding of Pennsylvania – named to honour his father, also named William. It would be helpful if he were called 'William Penn II' to save confusion.

Born to a wealthy London family, young William was expelled from Oxford University when, at about 17, he became, to his father's dismay, a Quaker and he kept to that faith throughout his life.

His links with Bristol were brief visits to help the Quakers who were being persecuted in the city that now claims him. His first wife died and his second marriage was to a Bristol Quaker, Hannah Callowhill. Hannah wished to stay in Bristol but Penn persuaded her to move to his estate at Worminghurst in Sussex.

He died at Rushcombe, another house he had purchased, near Twyford in Berkshire, and he is buried at Jordans in Buckinghamshire.

There is a monument to Admiral William

Penn, his father, in St Mary Redcliffe.

Whatever his credentials, Penn's own steadfast Quaker principles and his wish to establish religious tolerance – Pennsylvania was created to provide a refuge for Quakers – make his statue a welcome addition to the city.

Penn holds a paper on which is written 'Death is but a crossing the World as friends do the seas, they live in one another still'. □

29
Thomas Chatterton

Laurence Holofcener

Canon's Marsh Millennium Square
2000
Bronze
Owner: @ Bristol

This statue, Bristol's most recent tribute to Chatterton, presents him not on a pedestal but sitting casually, holding his last words.

There have been a number of attempts in Bristol to honour him since he died in 1770 when seventeen years old. His first verses were published when he was only ten. A few years later his 'Rowley Poems' were passed off as the work of a medieval monk. After a scandal he went to London where he took arsenic.

The first memorial to him no longer exists. It could hardly have been in greater contrast to the Holofcener bronze. Nikolaus Pevsner described this monument as 'a kind of Eleanor Cross'. A tiny figure of the young poet was perched on a six-metre Gothic tower, designed by the Bristol architect S.C. Fripp. This was erected in 1838 outside the north door of St

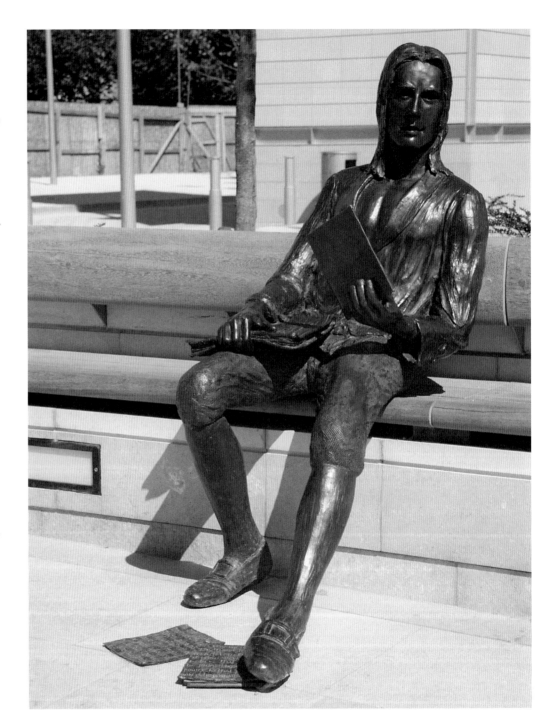

Chatterton *by Henry Wallis (1856)*

Mary Redcliffe. By 1846 the church had the monument dismantled and placed in the crypt.

In 1857, the year after Henry Wallis's renowned painting of Chatterton's death was exhibited at the Royal Academy, the memorial was re-erected on unconsecrated ground outside St Mary's, facing his birthplace. This worn structure was demolished in 1967. Fragments, including the figure, were discarded but an inscription was placed in the church.

Oscar Wilde made a pilgrimage to Bristol in December 1886 to see the school, then in Pile Street, that Chatterton was said to have attended. The Georgian school was not erected until nine years after Chatterton died. Wilde intended placing a dedicatory plaque on the building but it was not until 1897 that the Clifton Antiquarian Club postitioned the present inscription. This says 'THOMAS CHATTERTON POET ATTENDED THIS SCHOOL BORN 1752 DIED 1770'. The plaque may have helped in the preservation of the façade. It was moved, rather than demolished, when Redcliffe Way was constructed in the 1930s.

Chatterton's contribution to English literature was to inspire the leaders of the Romantic Movement and his life story was the basis of a novel by Peter Ackroyd in 1987. □

30
Paul Dirac

Simon Thomas

Canon's Marsh
Anchor Road outside the Explore Building
2000
Cement with glass fibre
Owner: @ *Bristol*

Small Worlds is an elaborately coloured cone commemorating a Bristol-born physicist, Paul Dirac. Appropriately the memorial stands outside the new science feature, called Explore.

Dirac was born in 1902 – the same year as Cary Grant and, like Grant, his career took him to America. In 1933 he shared the Nobel Prize for Physics with the Austrian scientist Erwin Schrodinger. He was the author of *The Principles of Quantum Mechanics,* the branch of science that describes the world at the level of atoms and molecules, and he predicted the existence of anti-matter.

The world of quantum mathematics is one that few can imagine and even fewer can enter. Dirac avoided the use of models or graphic symbols to describe his mathematical concepts. In making his sculptural tribute, Simon Thomas has used forms to suggest the progressively smaller and smaller worlds evoked by his title and a fascination and deep interest in science and mathematics imbue most of his sculptural work.

In 1995 he was appointed Artist-in-Residence at the University of Bristol's Physics Department. *Small Worlds* is the most ambitious public sculpture he has made so far. □

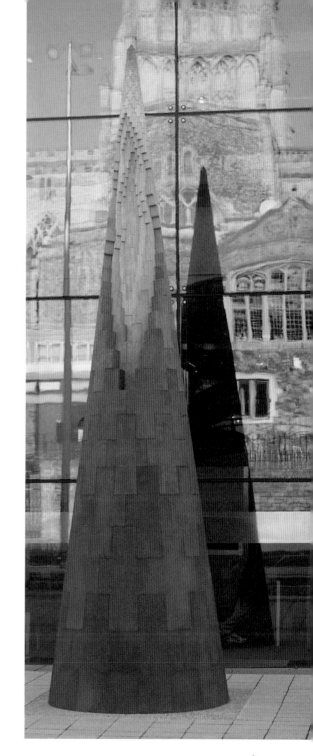

31
Cary Grant

Graham Ibbeson

Millennium Square
2001
Bronze statue
Cast by A.B. Foundry, London

Four Bristol businessmen campaigned for over two years to raise funds and commission this statue. It was the last public sculpture to appear in Bristol before this book went to press.

During September 2001 a Cary Grant Festival was held in Bristol and at the National Film Theatre in London. Many of Grant's films were screened – including *His Girl Friday* and *The Philadelphia Story,* both made in 1940.

Will this statue bring fans of the silver screen to Bristol, as the statue of Eric Morecambe has to his home town? That icon, erected in 1999, was made by the same sculptor. Ibbeson said he found the Grant statue the most challenging of all his commission in thirty years. He was relieved when his clay model was finally ready for the foundry.

Like Eric Morecambe, and many other film stars, Grant had changed his name. He started life in Horfield, as Alexander Archibald Leach in 1904, but while appearing on Broadway early in his career he decided to adopt the surname of the character he was playing and chose 'Cary' from a list approved by the studios.

His early years were tragic. His mother was placed in a mental hospital, without his being told, when he was only seven. On leaving school Archie found work in Bristol theatres – - one was the Hippodrome – before going to America with an acrobatic group and making his way in Hollywood in the mid-20s.

Only Charlie Chaplin made his way as an English film star in America as fast and as enduringly as Cary Grant. The film critic Mark Steyn said 'Archie Leach stepped beyond class, inventing the man he wanted to be' and 'as his contemporaries fade he remains indestructible, the all time greatest male movie star.'

He portrayed an Anglo-American of his own invention, not the stereotype 'Englishman in Hollywood' in the David Niven mode.

In 1974 Cary Grant was involved in commemorating Bristol in New York when he unveiled a plaque to record the fact that tons of rubble from bombed Bristol were taken in ships as ballast and used as foundations for the East River Drive highway. There is a copy of this plaque in the City Centre, close to the Hippodrome where he appeared as a teenager.

A large crowd was present on 7 December 2001 when Grant's widow, Mrs Barbara Jaynes, made a speech and unveiled the bronze. □

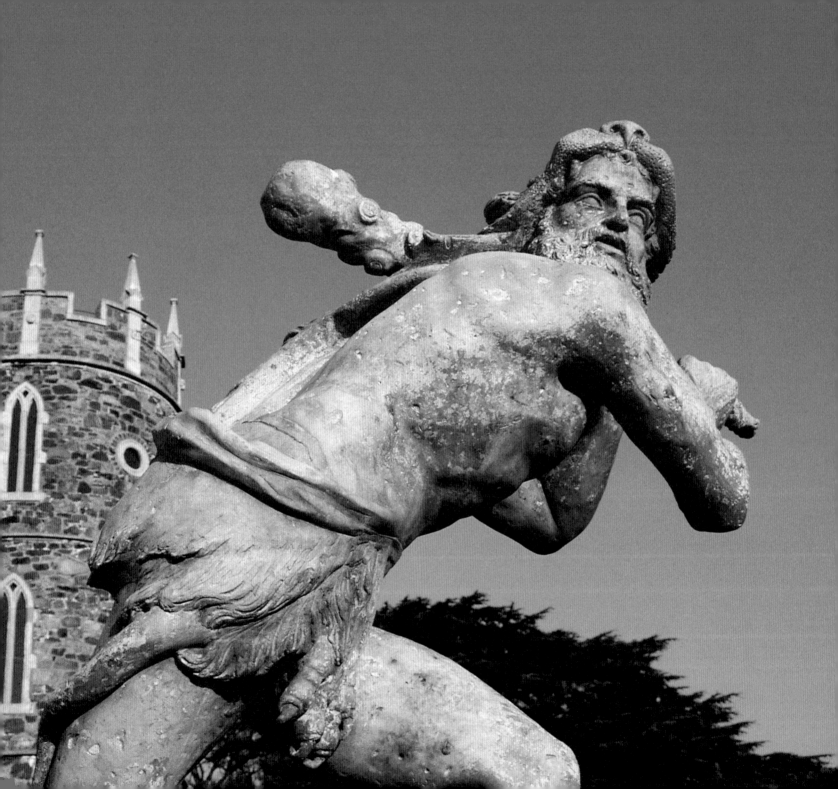

Decorative sculptures

The ornamental statue of Hercules in the garden of Goldney House, Clifton

32
Hercules

Attributed to John Nost

Goldney House, Clifton,
on the garden terrace, approximately
100 metres south of the house
Made c.1715,
moved to Goldney House c.1758
Lead on a limestone pedestal
Owner: University of Bristol
*Listed Grade II**

Bristol has two eighteenth-century lead giants –
Neptune (see opposite) in the City Centre and
this Hercules in the garden of Goldney House,
now owned by the University of Bristol. The
original house on the site was the home of the
Quaker merchant, Thomas Goldney III.

We cannot be certain that the sculptor was
John Nost the Elder, or where the statue came
from, but the year after Goldney died, in 1767,
the statue was listed in an inventory as 'One
Large Leaden figure of Hercules'. The terrace
where the statue stands was begun in 1753.

Sir John Vanbrugh designed King's Weston
House, only three miles to the west of Bristol
in 1710, and there are three pieces of evidence
to link this Hercules to that house. First, an
estate plan dated 1720 shows a statue of
Hercules on a central plot in front of the
house. Second, there is a drawing of the front
of King's Weston, made in 1746 by a Bristol
artist and school-teacher named James Stewart.
It is too small to identify the subject for certain
but the drawing shows a single male figure on a
pedestal. The third, and most convincing, piece

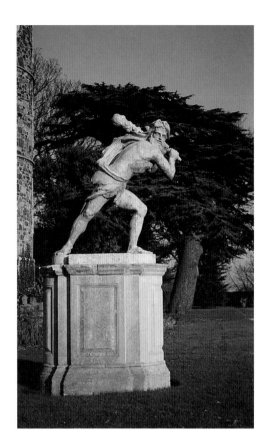

of evidence that the Goldney Hercules came
from King's Weston, is the similarity of the
pedestal at Goldney House to a drawing in a
book called *The Kingsweston Book of Drawings*.
A plan and elevation of the stone pedestal give
detailed measurements and these match the
pedestal on the Goldney House version.

Transporting the heavy statue could have
been done with relative ease by boat along the
river Avon. Both houses are close to the river
and there were moorings just below the house
at Clifton.

The University of Bristol restored the statue
in 1995, assisted by funds from the Alumni
Foundation.

The likelihood that the Bristol statue was
made by John Nost the Elder is strengthened
by the recent discovery of a similar measured
drawing in the archives of Hopetoun House,
near Edinburgh. This was sent by Nost to
accompany the statues of 'Baccus and Ceres'
he sold to the Earl of Hopetoun in 1709. □

Bristol Record Office

The measured drawing of the pedestal from
The Kingsweston Book of Drawings *is inscribed*
'Pedestal of Hercules at Kingsweston'. The dimensions
match those of the Goldney House statue.

33
Neptune

John Randall

City centre Centre Promenade
1722
Lead statue on a granite pedestal
Owner: Bristol City Council
*Listed Grade II**

For the most part, we enjoy an ample supply of clean water, with little thought. For centuries that was not so. The growth of the city and the survival of the citizens depended on bringing fresh water into the city.

Temple Conduit was one source of fresh water and this was the site where Neptune was first erected.

There is no evidence to confirm the identity of the sculptor. A bronze plaque on the pedestal says 'THIS LEAD-COVERED STATUE WAS PRODUCED BY JOSEPH RENDALL. FOUNDER. BRISTOL. 1723'.

The accounts for St Paul's Fair, held in 1722, are in the Bristol Record Office and these show the profits were used to maintain the conduit, to build a new cistern, and to pay a *John Randall* £32.10 shillings for 'the Figure Neptune & Peddistoll' (sic). This is a year earlier than the date on the plaque.

No records explain why the Roman God of the Sea was chosen for this early piece of public sculpture but he remains an appropriate icon for Bristol's seafaring associations.

Myths that the statue was raised to commemorate victory over the Spanish Armada in 1584 were repeated as late as 1872 when a plaque was fixed to the pedestal when

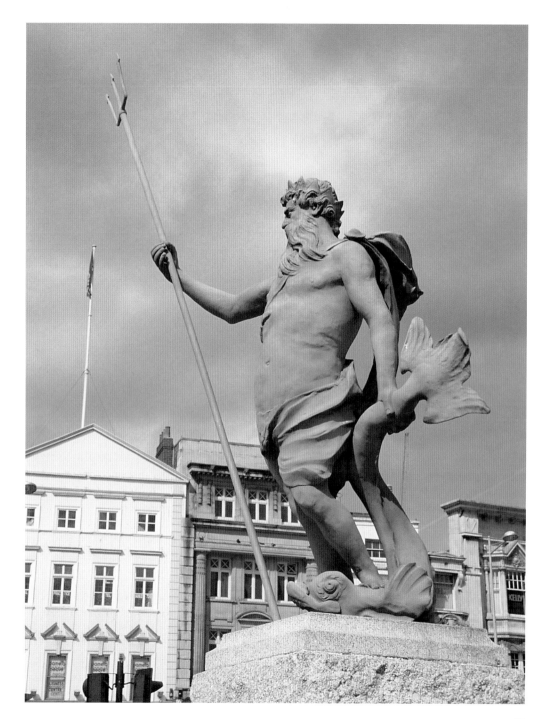

Braikenridge Collection/ Bristol Museum and Art Gallery

Bristol Record Office

George W Delamotte's painting of 1825 suggests that Neptune was painted in natural colours when he was still on his first site and a page from the accounts for St Paul's Fair say the statue and pedestal cost £32. 10s.

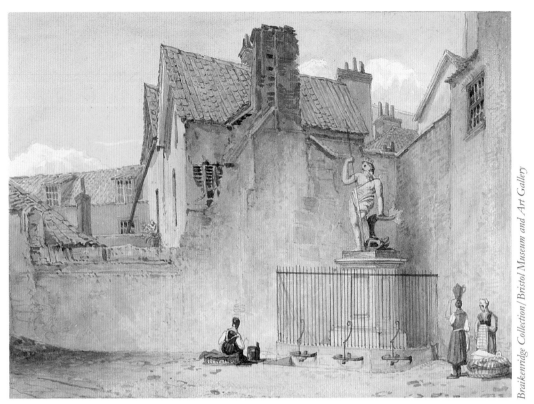

Neptune was moved to Victoria Street.

John Latimer, the noted Bristol historian, called this 'a remarkable illustration of the rapid development of local legends'.

Neptune has been on six sites in 280 years – more than any other statue in the city. At each move, repairs of some degree have helped to conserve him. Andrew Naylor, the conservator who tended him while he was still at Bridgehead in 1983, said the Bristol Neptune was a fascinating example of eighteenth-century lead statuary and probably unique. There are no other examples of statues by Randall, whether he was the sculptor, or founder, or both.

Until the early nineteenth century lead statues were often painted to look like marble, or they might be gilded.

Some were polychromed. Was the Bristol Neptune painted in this way? Bristol Record Office documents show 'Widow Maddox' was paid £2.12s for 'Paynting Neptune' and in a watercolour by George Delamotte (1825) the figure appears to be multi-coloured.

A polychromed Neptune would enliven his present coat of grey-paint. It does not look like lead and he now looks less significant against the large structures around him. □

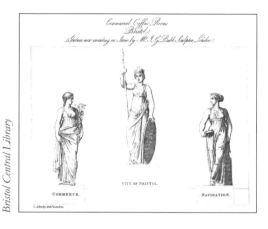
34
Commercial Rooms

James George Bubb

City centre
Corn Street on the façade of the Commercial Rooms
1810
Three stone statues and a marble relief
*Listed Grade II**

However austere this Greek Revival building appears it was nothing more than a coffee-house built to provide a club-like atmosphere for businessmen subscribers, just when Bristol's Floating Harbour was nearing completion in 1808.

The sculpture, three statues and a large marble relief expressed confidence in international trade in Regency England.

The architect, an admirer of Sir John Soane, and the sculptor were very young men and this was the first important commission for

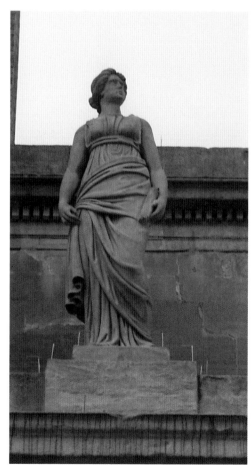

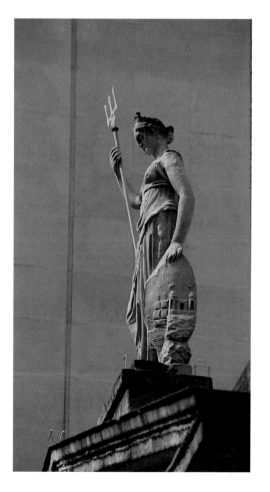

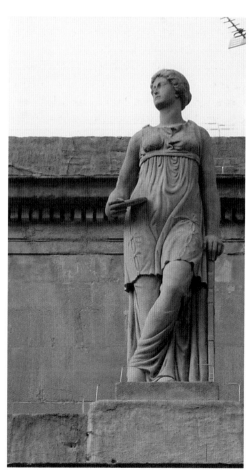

Charles Augustus Busby (1788-1834). Aged only 21, he won the competition to design the building in 1809 and invited James George Bubb (1782-1853), a fellow student from the Royal Academy Schools, to make the sculpture. Opened in 1811, the rooms were considered to rival Lloyd's Coffee House in London.

Who do Bubb's three figures personify? An early engraving by the architect – so early that the caption reads 'Statues <u>now</u> executing in Stone by Mr. J. G. Bubb. Sculptor. London'

tells us that *Commerce* is on the left, the *City of Bristol* is in the centre and *Navigation* is on the right. In the engraving the central figure originally held a spear but she now has a trident, making her look like Britannia. The arms of Bristol are just visible on her very worn shield. From the street the attributes of the figures are difficult to identify but *Navigation* leans on a ship's rudder and *Commerce* simply holds a scroll.

Rupert Gunnis, the sculptural historian,

described Bubb's carving in the portico as 'a delightful bas-relief' and the six metres of white marble are still in excellent condition. Britannia is the central figure and here, supported by Neptune and Minerva, she is receiving tributes from the Four Corners of the world – which she then dominated. Bubb also carved the ornamental chimneypieces inside.

Bubb has similar work on major buildings in London – the reliefs on the London Custom House and statues on the Royal Exchange. □

Photograph: Stephen Morris

Art among the pigeons. Even though it is set deep inside the portico of the Commercial Rooms, this marble frieze requires netting as protection

35
Goddess of Wisdom

Musgrave Lewthwaite Watson

Clifton, Queen's Road
In the pediment of the Victoria Rooms
1841
Relief in Bath stone
Owner: University of Bristol
*Listed Grade II**

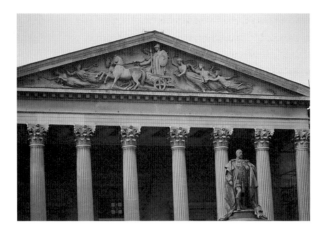

What a prized commission this must have been but, strangely, no evidence has been found to reveal the identity of the sculptor. Ironically, the architect's name, Charles Dyer, is unusually prominently on the frieze.

Classical sculpture is now less understood, less appreciated, but this work is outstanding. The art historian, Benedict Read, says the Bristol pediment is a superb design – among the best of hundreds of British examples – better than the British Museum pediment by Sir Richard Westmacott.

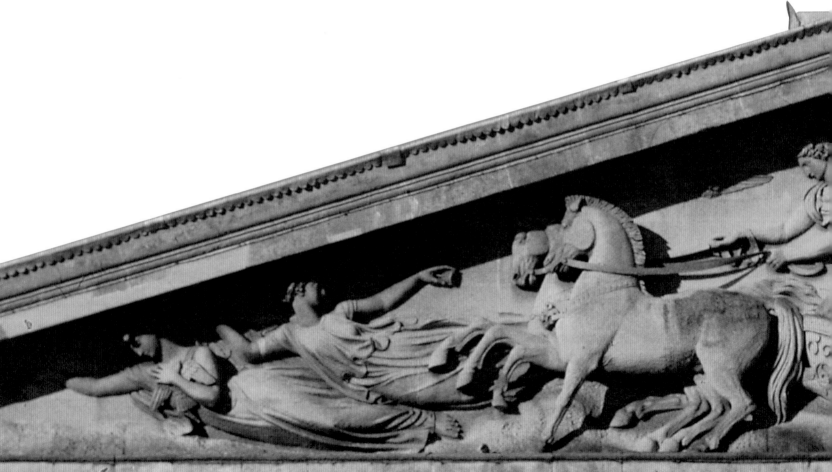

So who might the sculptor have been? The design has often been attributed to 'Jabez Tyley', a member of a family of sculptors and masons that flourished for about two centuries in Bristol.* But in his book *Victorian Sculpture* Benedict Read considers this design beyond Tyley's ability and believes it is by Musgrave Lewthwaite Watson.

Watson's biographer, Henry Lonsdale, visited Bristol in 1865 and reported that using binoculars he saw the name 'T. Tyley'. * If this was correct, the name must have been removed. Later Lonsdale interviewed Tyley who first said the work *was* his but later confessed he was contracted to carve from Watson's plaster model. Lonsdale called this 'local chiselling by a Bristol burgher'.

Watson lived for six years after the building opened but there is no record that he disputed the misrepresentation. Lonsdale concluded, 'It is to be hoped that Mr. Dyer . . . will endeavour to see justice done to Watson as the designer of a highly decorative work that gives character to one of the best edifices in Bristol.'

The sculpture has had several titles – *Advent of Morning, Dawn* and *Athena driven by Apollo.* One description says, 'The Goddess of Wisdom is in a chariot drawn by horses. Music, Poesy, and Light, and her emblem of an owl guides her. Following in her path are the Graces, strewing flowers. In front, Night clasps an owl with her right hand, while Morning extends an hourglass towards the horses of Aurora.'

The reasons for the many compliments can best be seen in low afternoon sunlight.

A massive relief, *The Battle of St Vincent,* by the Cumbrian sculptor Musgrave Lewthwaite Watson, clearly signed, can be seen on the west face of the pedestal of Nelson's column in Trafalgar Square.

Among those appearing in the Victoria Rooms' days of glory were Charles Dickens, Sarah Bernhardt, Oscar Wilde, Sir Arthur Sullivan, Ellen Terry and Winston Churchill. □

*A marble monument to Major Gore in the north aisle of Bristol Cathedral is inscribed 'T.Tyley'

36
Bristol with Minerva

Edward Hodges Baily

*City centre
in the portico of The Masonic Hall,
Park Street – originally the
Philosophical Society and Institution
1824
Carrara marble
Owner: Provincial Grand Lodge of Bristol
Listed Grade II**

Baily's *Minerva* frieze, carved in London, dates from a period when Bristol was expanding as a centre of science and the arts. This sculpture is inextricably bound to the history of the building for which it was made.

Humphry Davy came to work at the Pneumatic Institution in Dowry Square in 1798 when he was only 19 but he swiftly became a strong influence on the scientific and literary life of the city. Before his outstanding abilities took him to London he proposed that an Institution for the Advancement of Science and Literature would be of value to Bristol. By 1820 this became a reality.

Painting of E.H. Baily by his son, William.

Baily was only 36 years old when he presented this relief to his native city but he was clearly proud of establishing himself in the capital

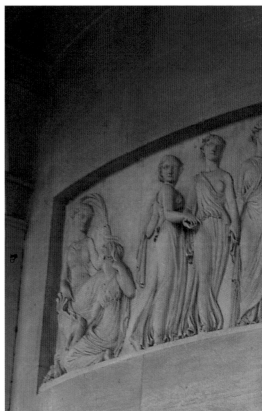

The sculptor E. H. Baily was another rising star. His ability had taken him to London from Downend, east of Bristol, where he was born in 1788. His fame has waned but his statue of Lord Nelson in Trafalgar Square reveals his status. By his early thirties, as a brother Freemason, he was able to present *Minerva* as a gift to his native city. Was the inclusion of 'London', so prominent on the frieze, a reminder to Bristolians of his success there?

An early Philosophical Society share certificate describes the panel: 'Apollo and Minerva are introducing the Arts and Sciences and Literature to the City of Bristol. Bristol, seated on the Avon, receives them under her maternal protection and dispenses to them encouragement and rewards, whilst Plenty unveils herself to Peace, since under their happy influence, those explanations of the human intellect flourish and improve.'

Bristol freemasons purchased the building in 1871 and since then they have cared for the panel. A Grand Master, Sir Ernest Henry Cook, * wrote a history of the hall in 1939: 'Due to its even and heavy covering of soot for many, many years, the Panel must have been passed unnoticed and entirely unappreciated by many who have an eye for such things.'

With foresight he added, 'It is hoped that in future years it may escape the fate it has suffered in the past, and that legislation with regard to smoke abatement may render this possible.'

This secluded treasure survived more than soot. Bombs destroyed most of the building in the Second World War but the colonnade and the frieze were spared. □

* Cook's interest in sculpture was long-term. In 1914 he visited the sculptor Henry Poole's studio to inspect models for the lions now outside the Victoria Rooms. (see page 39)

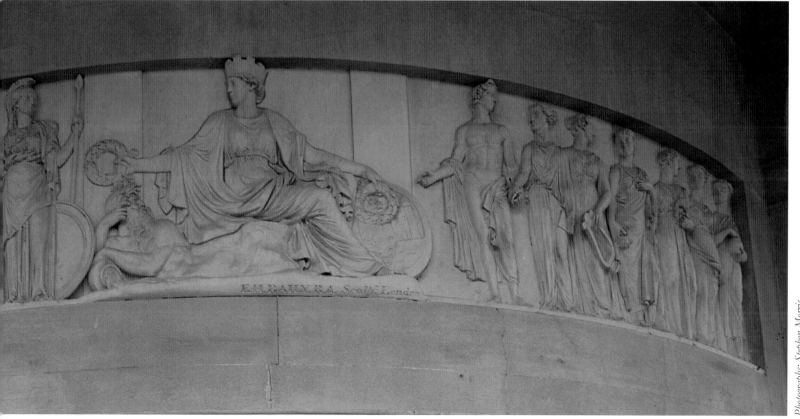

Photographs: Stephen Morris

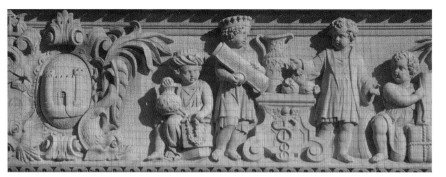

37
Lloyds Bank

John Thomas

City centre
Corn Street
1854-58
Bath stone with Portland stone insets
Owner: Lloyds Bank plc
*Listed Grade II**

The façade of the West of England and South Wales Bank was encrusted with sculpture to reassure customers of its wealth and prestige. When the bank opened *The Builder* commented, 'If any architectural attraction could reconcile a man to any rate of discount, no customer should ever go away dissatisfied.' There were 42 branches when it crashed after twenty years.

The variety and quantity of sculpture is to modern eyes bizarre but every object and figure is an emblem that represents a clearly identifiable association with the original bank's interests in the West Country and South Wales. In an effort to portray professions, agriculture and industries the imagery has been described as 'stereotyped' and 'three-dimensional stage

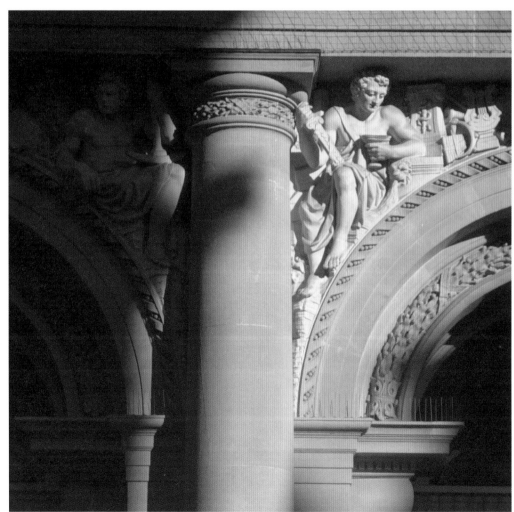

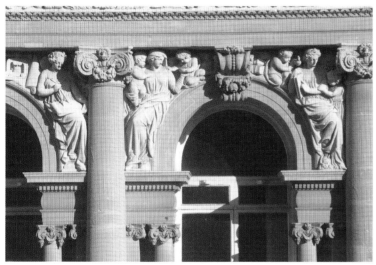

scenery'. Much is fanciful – to the point of the comic. Originally five large keystones on the ground floor – a bay was added at a later date – represent the sea and river gods; the Bristol Channel, the Avon for the Bath office, the Exe for Exeter, the Usk for Newport and the Taff for Cardiff. In the ground floor spandrels are semi-nude, muscular men representing the chief products of the area in which the bank operated – industry and agriculture, shipbuilding and much else. On the first floor draped females proclaim Justice, Charity, Integrity, Education, Art and Science – everything from music to motherhood.

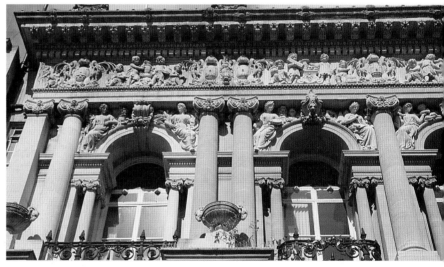

In the upper frieze *putti* are busy die-sinking coins, printing money, and book-keeping in the manner of the elves in Santa's workshop.

The white sculpture is in Portland stone and the remainder in Bath stone from quarries at Hampton Down, Combe Down and Box.

The architects who gave the sculptor this opportunity were the Bristol partnership of William Bruce Gingell and T. R. Lysaght. The inspiration for their mid-Victorian opulence was a Renaissance building – the Library of St Mark, designed by the City Architect of Venice, Jacopo Sansovino, over 300 years earlier. Architectural historian Tim

Mowl has praised Thomas for carving 'even more richly and more robustly than his Venetian precursors'. Thomas was born at Chalford, near Stroud in Gloucestershire. His obituary said he had 'more employment than he could cope with, and the attempt to do so wore him to his premature death'. His other commissions in Bristol alone confirm this – figures on the Guildhall and the Assize Courts (1843-6) in Broad Street and the façade of the Royal West of England Academy built in 1857. (see page 22) It is not surprising he died at 49 having supervised the sculptural work on the Houses of Parliament and Euston Station. □

38
Aesop and La Fontaine

Sculptor unknown

Elmdale Road Tyndall's Park
c1884
Owner: Various companies

1

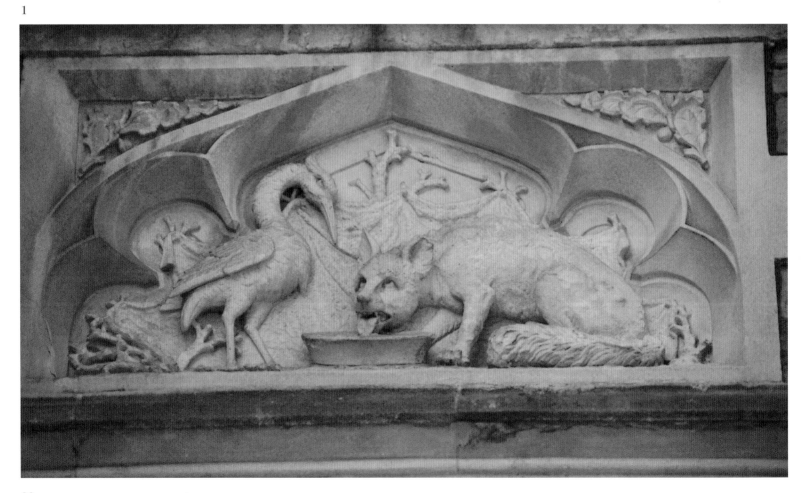

Many Victorian and some Edwardian houses have carved stone or terracotta-moulded ornament but few have such individual sculptures as those on a group of four houses in Elmdale Road. The subjects are scenes from the fables credited to Aesop (sixth-century Greece) and the French writer Jean de la Fontaine (1621-1695).

The architect set three deeply-cut relief panels on each of the bays above the ground floor windows of each of the houses.

Some of the fables can be clearly identified. The two side panels (**1** & **2**), on No.11 relate to the La Fontaine fable about a fox that invites a stork to dinner. The fox serves soup on a shallow dish and the stork gets nothing; the long-beaked stork invites him in return and puts small pieces of meat in a long-necked jar.

The centre panel (**3**) on the same house has the well-known Aesop fable *The Tortoise and the Hare* – the hare sleeps while the tortoise wins.

House No.10 has another Aesop fable on the right-hand-side relief (**4**), *The Raven and the Snake*. Here the bird has swooped up a sleeping snake as a meal but the snake twists round and fatally bites it.

La Fontaine's fable of a monkey who gets a cat to snatch roasted chestnuts from a fire for him is in the centre panel of No.9. (**5**)

In the past few years the panels have been cleaned and conserved. The names of the architect, builder and the mason who created them have been sought but not discovered. □

2
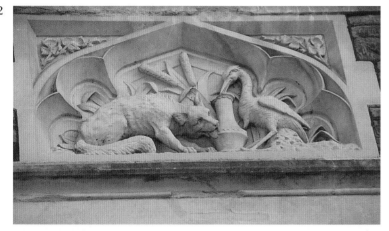

3

4
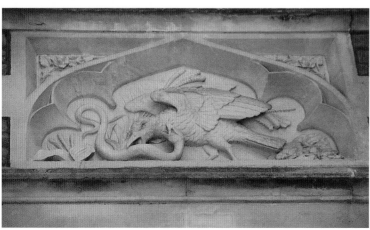

5
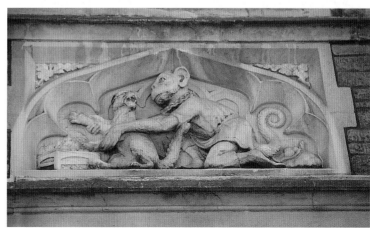

39
Bristol Museum & Art Gallery

W J Smith

Clifton, Queen's Road
Bristol Museum and Art Gallery
1905
Three limestone figures
Owner: Bristol City Council
*Listed Grade II**

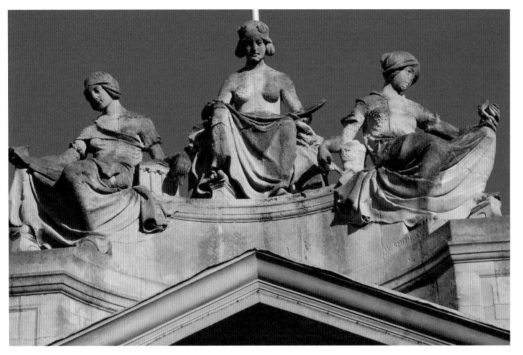

Below: Postcard of Bristol's new museum in 1906

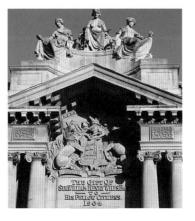

The beginning of the twentieth century was a prosperous time for Bristol, especially for the Wills family. Led by Lord Winterstoke they provided the entire expense of the new Museum and Art Gallery. Sir Frank Wills, a cousin of Lord Winterstoke, was the architect. He commissioned this Bristol sculptor to design and carve three female figures to crown the façade of the gallery, provocatively described as 'hefty Baroque' by Sarah Whittingham in the University of Bristol's magazine, *Nonesuch*.

The figures have been referred to as *The Three Arts* and the objects they hold, although far above the ground and difficult to see, seem to identify their roles. On the left is *Architecture*, studying a plan while she rests on a model of a classical temple. The central figure, *Painting*, has a palette and she may once have held a paintbrush. *Sculpture* has a mallet and she also holds a statuette. This has lost the upper part of its body. After nearly a century of weathering the trio is eroded but 'W. Smith.Sᶜ' is well defined beneath the female on the right.

Smith carved these 2.45-metre figures *in situ*. It is said he fell during the work, was seriously injured and became deaf as a result of the accident. He did more sculpture inside the museum and was responsible for the lions at the foot of the staircases in both halls. The statue of a *Madonna and Child*, high in a niche in the west façade of St Mary's Hospital at Upper Byron Place, is also his work. □

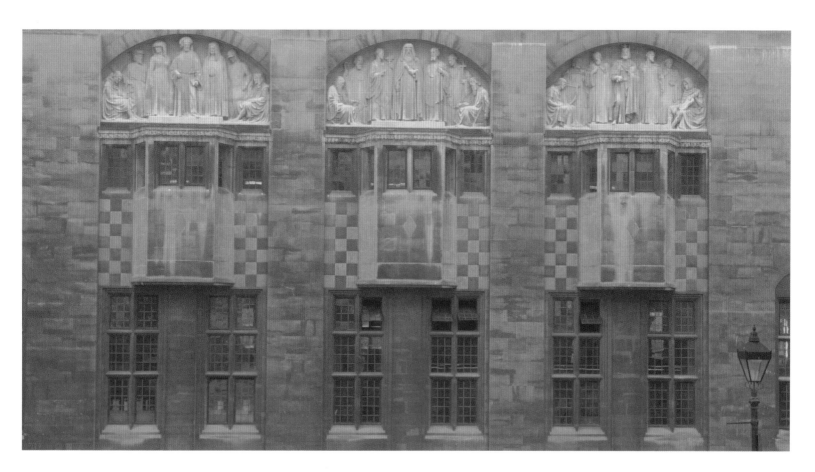

40
Bristol Central Library

Charles James Pibworth

College Green, Deanery Road
on the façade of the Bristol Central Library
1906
Portland stone
Owner: Bristol City Council
Listed Grade I

Here is another major sculpture by a Bristol-born artist. Charles Pibworth (1878-1958) was only 26 years old when he carried out this commission for the architect Charles Holden. Holden's design of the library was described by Andor Gomme as 'one of the great masterpieces of the early Modern Movement'.

Although he had worked with Holden before – he made figures for the Law Society building in London in 1904 – Pibworth must have been delighted by this early success in his home city.

All twenty-one figures can be identified. The central panel includes the *Venerable Bede*

and *St Augustine* as contributors to English religious literature and the right-hand panel has *King Alfred* at the centre. *Chaucer, The Wife of Bath,* and other Canterbury pilgrims fill the remaining relief. The three Pibworth panels were cleaned and carefully protected from the birds in early 2001.

When Pibworth wrote to the Lord Mayor of Bristol in the autumn of 1910 he knew that the Council had decided to erect a statue to the late King Edward VII. Although he was living at 14 Cheyne Row, Chelsea, he put his Bristol address, 64 Beauley Road, Southville on his London letterhead. 'I write to you hoping that,

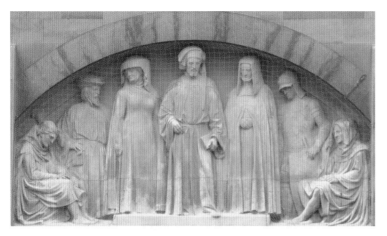

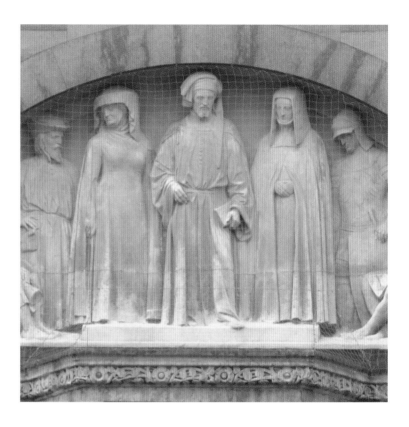

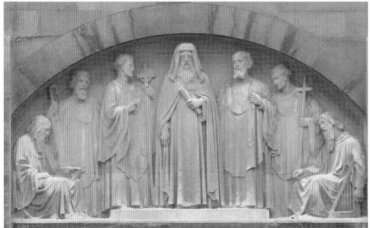

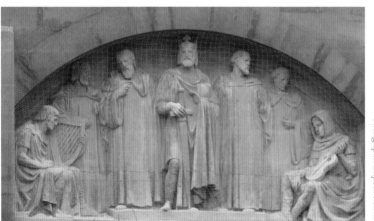

Photographs: Stephen Morris

Bristol Library Relief Panels/ continued

as I am a Bristolian, I may have the honour of being chosen as your sculptor.' He then cited 'the three Gothic figure panels on the Bristol Central Library, containing 21 life size figures, which I designed & executed, so pleased the Committee that they presented me with a cheque for £50 over the sum stipulated.'

He was one of twenty sculptors to submit a model for the statue of the king in the Edward VII Memorial competition in April 1911 but his design was not successful. (see page 36).

41
Nine Muses

Reginald Jeffcoat

Clifton
University of Bristol
over the doorway to the Wills Memorial Building
1925
Clipsham stone from Rutland
Owner: University of Bristol
*Listed Grade II**

The new University of Bristol buildings began on the eve of the First World War as a memorial to Henry Overton Wills, paid for by his sons. The architect, Sir George Oatley, managed to create a building highly regarded as free interpretation of medieval architecture rather than a rigid copy.

The masons, mostly anonymous, were allowed great freedom. The designer of the group of *Nine Muses* is known. He was the Reverend Reginald Jeffcoat, a curate of Christ Church with St Ewen, Broad Street.

Most of the tower is in Bath stone, from quarries near Box in Wiltshire, but the statues and more elaborate carvings are in the harder, more resistant, Clipsham stone from Rutland.

Jeffcoat was an amateur artist and he designed a number of other sculptures in Bristol. There is a statue of St Michael slaying a dragon, designed and carved by Jeffcoat in the church where he was a curate, a marble fireplace in the Georgian House, Great George Street and a number of other commissions.

The names of the daughters of Zeus appear beneath each figure. Calliope is the muse of epic poetry, Clio represents history, Erato love poetry. Euterpe is the muse of lyric poetry, Melpomene of tragedy, Polyhymnia of sacred song, Terpsichore of dance, Thalia of comedy and Urania of astronomy. □

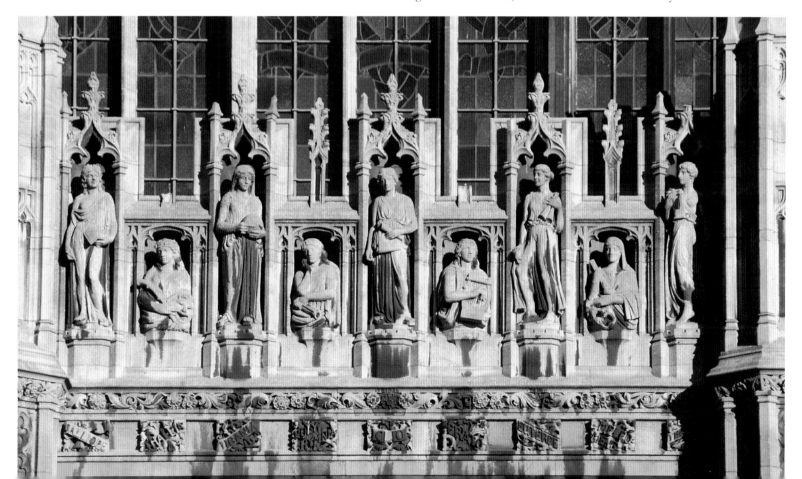

42
Peace and Plenty

Hermon Cawthra

City centre
on the façade of 37-39 Corn Street
1935
Two Portland stone relief carvings
Listed Grade II

Outside London, sculpture of the 1930s is under-represented in most British cities. This Bristol example, from the period of depression and the prelude to the Second World War, was created in 1935 when Friends' Provident and Century Life Insurance Company commissioned Sir Charles Gilbert Scott, RA, PPRIBA, to be the consultant architect for the front elevation of their new building, while A. W. Roques, FRIBA, was the architect responsible for the interior.

Use of the human form to personify attributes like 'Strength' and 'Wisdom' was commonplace in Victorian and Edwardian sculpture but by the early twentieth century the convention was exploited far less. Here the sculptor Hermon Cawthra has set *Peace and*

Plenty to the left of the central window on a pilaster. *Peace* gazes at a pair of doves on her shoulder and steadies her right hand on a large cornucopia spilling its contents at her feet. *Benevolence and Prudence* is to the right. *Benevolence* holds an olive branch and, with her head bent, she places her hand lovingly on the head of a naked standing *putto*. Standing on a bag of coins he proffers what seems to be a money box. Both the female figures appear as if gently draped in fine diaphanous cloth. All this is very restrained when compared to the mass of humanity on what is now Lloyds Bank further up Corn Street. (see page 78)

The building, originally offices, next became a bank and is now a restaurant. A pleasing improvement, suggesting the present owners do value Cawthra's carving, is the installation of spotlighting to feature the reliefs at night.

Above the main door on the ground floor is a shiny metal grille with chorus-line of maidens dancing before a figure representing 'Wisdom'. In October 1935 an issue of *The Builder* described this period piece, part of Gilbert Scott's original scheme designed by A. Crompton-Roberts and R. Pryce Roberts, as a 'Birmabright' casting. □

43
The Bristol Unicorns

David McFall RA

City centre College Green
on the roof of Bristol Council House
1950
Two cast bronze and gilded sculptures
Owner: Bristol City Council
*Listed Grade II**

When the gilded sculptures, 3.6 metres high, were about to be hauled into position there was a rumpus in local and national newspapers. On 25 October 1950 the front page of *Bristol Evening Post* described them as 'gleaming, lantern-jawed, wild-eyed, stiff-legged'. The architect, Mr E. Vincent Harris, had ordered them without informing the Council and, even worse, he was on holiday in Italy! Another Bristol paper said: 'No one knows, or at any rate no one will say, who ordered the unicorns and why placing them on the roof was stopped'. The City architect, J. Nelson Meredith, told the press, 'The whole thing is a complete mystery to me. Unicorns have never been mentioned for the Council House. I do not know who ordered them'. The *Western Daily Press* contacted David McFall in his Glebe Place studio in Chelsea but this 'threw no light' on the enquiries.

Installation of the sculptures was halted until a Council meeting accepted that the unicorns *had* been considered in the planning stages but shelved when war intervened.

When Vincent Harris (he was 71 at the time) came back to Bristol he explained to the Council that he had commissioned the unicorns, at the cost of £2,400, in place of 'a long and expensive ornamental ridging that would have cost £600 more'.

We should applaud Harris's autocratic behaviour on this occasion because half a century later they sparkle splendidly on a sunny day and the Council House would be duller without them.

The unicorns are identical. They are set facing each other. McFall's single 44.5 cm model was exhibited at the 1951 Royal Academy Summer Exhibition and is now displayed in the Mayor's parlour.

Why unicorns? They have been significant to Bristol since unicorns first appeared as supporters on the city's common seal in 1569. In heraldry they have many attributes but the city chose them to represent virtue; the city motto is '*Virtute et industria*'.

Listing the Council House as Grade II* in 1981 English Heritage praised the building as 'An important work by the most celebrated civic architect of the first half of the C20' but described the unicorns as 'Epstein sculptures'.

Two Portland stone finials, on the rear parapet, of a boy and a girl riding seahorses are also by David McFall. □

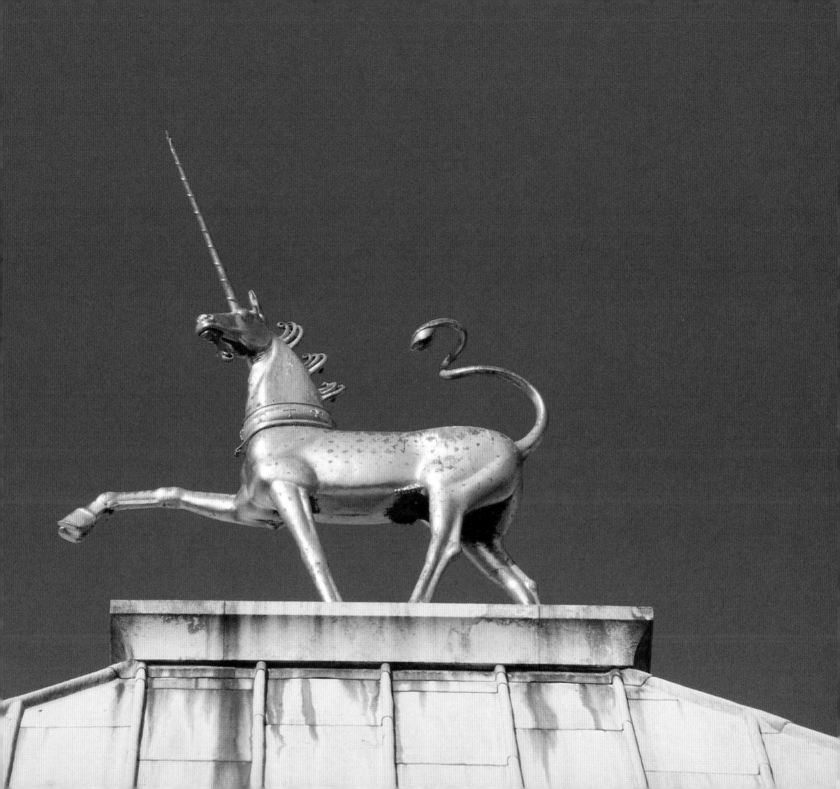

44
An Elizabethan Seaman

Sir Charles Wheeler

City centre
College Green In the central arch of the
Council House
1952
Portland stone
Owner: Bristol City Council
*Listed Grade II**

A brochure produced when Queen Elizabeth II opened the Council House on 17 April 1956 describes this statue as 'a symbolic figure of an Elizabethan seaman carved in Portland stone by Mr Charles Wheeler, RA'. The Council maintains the statue does *not* represent the city's renowned explorer, John Cabot.

The sculptor thought otherwise. In the catalogue of the Royal Academy Summer Exhibition for 1952 he exhibited the work as 'Number 1423. John Cabot – sketch model for the statue on the New Council House, Bristol'.

Look carefully at the bearded figure. He wears clothes suggesting those of a very wealthy man of the fifteenth century – a deeply pleated, knee-length, fur-trimmed coat, with a large collar. In his left hand is roll of paper with a seal. Could that represent a Royal Charter? On his belt hangs an astrolabe – a

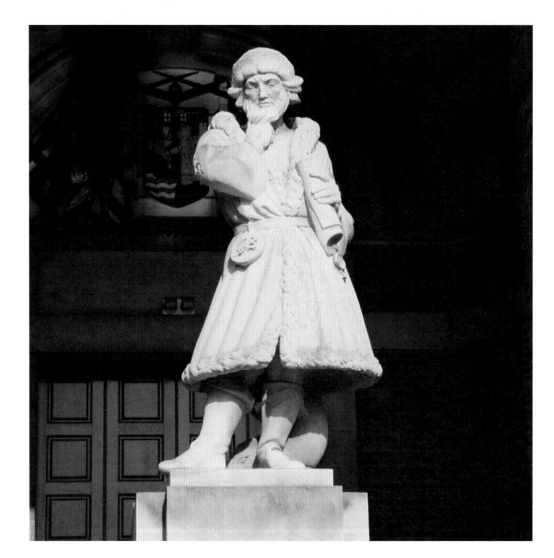

navigational instrument for measuring the altitude of the sun or stars. A shield with the arms of Bristol is carved on his coat.

A Bristol brewery approached the Town Clerk in the 1950s for permission to include the statue in an advertisement for the company's beer, called *Cabot Ale*. Not surprisingly, a Bristol City Council Meeting

refused the request. Minute No.52, 18 October 1951 (confusingly headed *The Cabot Statue*) says 'the committee was not prepared to agree'.

Figures on the fountain to the west side of Trafalgar Square, designed in 1948, are among Wheeler's best-known public works but his largest public sculpture commission was for the Bank of England. □

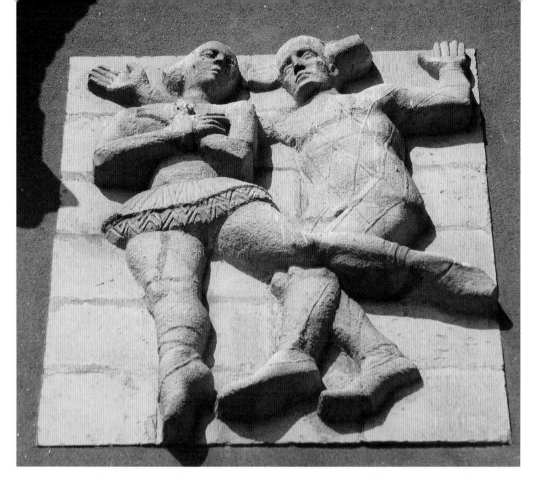

45
Colston Hall Reliefs

Sculptor unknown

City centre
Colston Street
c.1960
Deep relief built of irregular limestone blocks
Owner: Bristol City Council
Listed Grade II

The first concert hall was built in 1867 on land where Edward Colston's school had stood for 160 years.

John Foster and Joseph Wood, a Bristol partnership, were the architects. When the façade was completed in 1873, as part of the second stage, the first floor consisted of a deep arcade of seven arches with large windows.

The hall was almost destroyed by fire in 1898 and was re-built in 1900 but then devastated by a second fire in February 1945.

At the time of the 1951 Festival of Britain the city architect, J. Nelson Meredith, redesigned the hall, and it was enlarged to seat an audience of 2,180 as part of Bristol's celebrations. Then, around 1960, when the interior was altered, the windows in the arches were filled in and these three relief panels, depicting wrestling, music and ballet, were probably commissioned to decorate alternate insets on the façade. The sculptor's name was not confirmed at the time of going to press.

The style of the relief panels appears to be of the 1960s but the dancers' costumes are reminiscent of designs produced by Leon Bakst and others for Sergei Diaghilev's Ballet Russe that flourished in Paris from 1909 to 1929. □

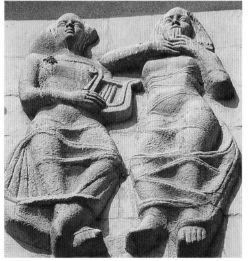

46
Sainsbury's

Barbara Ash

Ashton Vale Sainsbury's Superstore
Winterstoke Road
1991
Bath stone reliefs
Owner: J. Sainsbury plc

Sainsbury's have commissioned sculpture for nearly all their modern superstores. In doing so they have employed an exceptionally wide range of artists and used many kinds of materials and extremes of scale.

Barbara Ash carves her own work and these deep relief panels at Winterstoke Road were her first public commission. They are set in a brick wall just above the height of shopping trolleys and they depict, in an innocent, child-like vision, four instantly recognisable views of Bristol. In one panel the sculptor shows the Cabot Tower with Festival hot-air balloons drifting among the clouds. In another, cloud-like birds and bird-like clouds float above the ss *Great Britain*. A dreamy observer gazes across the Avon Gorge towards the Clifton Suspension Bridge in the third panel. The fourth features the jib of the Fairbairn Steam Crane (1876), close to the Industrial Museum. In 1976, the hundred-year-old crane was scheduled as an Ancient Monument. □

Fountains and water features

47
Queen Victoria Fountain

W & T Wills

This is the longest surviving drinking fountain in Bristol and it was erected soon after London's first free street drinking fountain appeared at Snow Hill, Holborn. A painting of the London version, *The First Public Drinking Fountain* by W. A. Atkinson (1859), exists but, unlike the Bristol fountain, the original was destroyed.

Most of these reminders of Victorian life are in poor condition and they rarely function. Vital in their day, they provided fresh water and helped to control cholera and other diseases. Bristol's mid-century epidemics caused many deaths. Providing 'Adam's ale' in this way also encouraged temperance.

One of Reece Winstone's books contains a photograph taken before an inscription, fixed to the lower part of the fountain, was broken off and lost. Without that photograph we would not know 'John Payne Budgett' made this gift to the city, or the date, 1859 – the year The Metropolitan Free Drinking Fountain and Cattle Trough Association was founded. Budgett was a member of a prominent business family in Bristol. Little is known about him beyond this generous act but he was probably a temperance campaigner.

Although this cast was merely a stock item, made by the Coalbrookdale Foundry, one of a variety of patterns that could be selected from a catalogue, *The Art-Journal* of 1860 praised the work. 'It is to the Messrs. Wills Brothers, of

Bristol Central Library

From an issue of The Art-Journal *of 1860*

Euston Road, that the promoters of drinking fountains . . . are eminently indebted for the ability, skill and earnestness with which they have directed their thoughts to the production of iron fountains . . . These gentlemen, sculptors by profession, and artists of no common ability have considered the production of iron drinking fountains to be of sufficient importance to form a distinct class of Art- manufacture'. *The Art-Journal* printed wood engravings of the Bristol fountain and three other styles. Has any other casting of the Bristol version survived?

Coalbrookdale Foundry has links with Bristol, originating from the Bristol Iron Company of 1708, set up by Abraham Darby, the first man to smelt iron ore with coke. His financial backers for many years, before and after he moved to Shropshire, were the Goldneys, prosperous Bristol Quakers who owned the statue of *Hercules.* (see page 68) □

48
Alderman Proctor Fountain

George and Henry Godwin

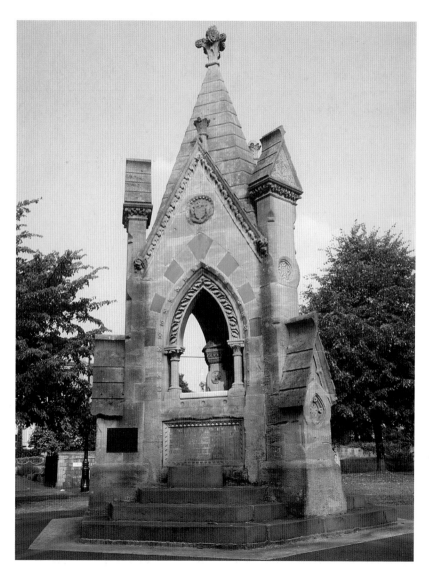

Alderman Proctor's Drinking Fountain/continued

Clifton Down Bridge Valley Road
1872
Box limestone, Red Mansfield and
Rouge Royal marble
Owners: Bristol City Council
Listed Grade II

This large triangular Gothic-style monument
was presented to the city by Alderman Proctor
to mark 'the liberal gift of certain rights over
Clifton Down . . . to the citizens of Bristol
forever.' The Society of Merchant Venturers
had presented the downs to the citizens of
Bristol in 1861 and Proctor's gift of the
fountain followed a decade later.

For over a century the 7.75 metre-high
drinking fountain, described as 'shrine-like',
was on the site of the old Clifton Turnpike at
the top of Bridge Valley Road by the junction
with Fountain Road. As traffic grew the
fountain obstructed visibility and, after some
fatal accidents, it was moved to the present
position in May 1988.

The new site is closer to what was Thomas
Proctor's private home. London architects,
George and Henry Godwin, designed the
fountain and the house. Proctor later presented
this to Bristol for use as the Mansion House.

Fresh water was available from three taps
and Proctor said these were sufficient for the
'thousands who visited the downs on Sunday
afternoon or evening . . . but to meet any extra
demand, my man takes out a number of half-
pint mugs.' Drinking water was issuing from
all three taps in September 2001.

Under the pseudonym *'Nil desperandum'*,
Proctor donated funds to enable large-scale
renovations to St Mary Redcliffe. □

49
Simon Short Fountain

Designer: Tom Dove

Hotwells Trinity Place at the junction of Hotwell
Road and Merchant's Road
1902
Painted cast iron. Trough, basin and pedestal of
Peterhead granite. Steps of Rhudcairn red granite.
Owner: Bristol City Council
Listed Grade II

Mike Pascoe, an ardent local historian and
member of the Clifton and Hotwells Society,
has only recently found details of the unveiling
in a 1902 copy of the *Western Daily Press*. This
account has the full text of the now illegible
inscription on the memorial's plaque: 'To
commemorate the life work of Simon Short,
who for over half a century, as seamen's
missionary in this port and superintendent of
the Bethel Ship, and as the pioneer of the
Cocoa Rooms and the Coffee Tavern
movement, devotedly laboured for the people's
welfare. This fountain is presented to his native
city by many of his fellow citizens and
Members of the National Temperance
Caterers' Association.'

A temperance association conference, held
in Sheffield in May 1901, had resolved that a
permanent memorial should be erected to
commemorate 'the unique and devoted
services rendered to the community by the late
Mr. Simon Short, of Bristol'. On Saturday 13
September 1902 the Lord Mayor of Bristol
(C. E. L. Gardner) unveiled the fountain on a
triangle of land, planted with trees, on the

Simon Short – 'a perfect likeness' said his relatives

Hotwell Road at the foot of Granby Hill. When the flyover system was created in the early 1960s the fountain was taken into store until it was re-erected on the present site in 1966. Planning permission granted for the flats, built on the corner of Merchant's Road in 1981, ensured the memorial was retained.

The fountain was designed by a Birmingham architect, Tom E. Dove, and he decorated the capitals on the metal columns that support the canopy with cocoa beans and leaves. The relief portrait, made by Jones and Willis of London and Birmingham, was on the same side as the plaque. On restoration it was fixed to the back.

The whole fountain has something of the form and charm of the Wallace drinking fountains that decorate the streets of Paris. □

50
King George V Memorial

Sculptor unknown

City centre Narrow Quay
1980
Red brick arch with Portland stone figures
Owner: Bristol City Council

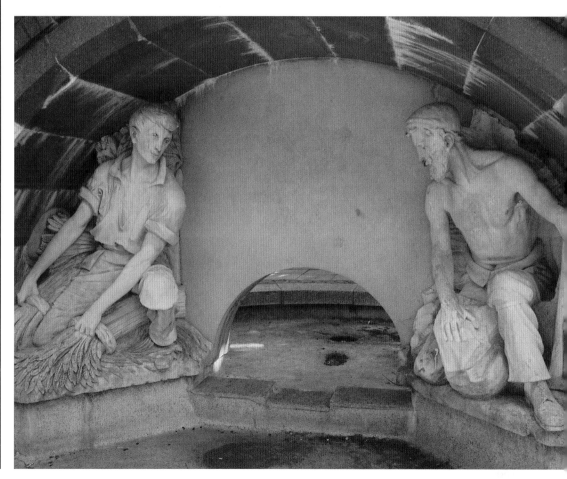

Bristol's statues of Queen Victoria and King Edward VII are well known but this memorial to King George (1910-1936) can easily be overlooked. When found its two sides and lack of obvious associations to King George may confuse the viewer.

Although the King George V Memorial Fund Trustees raised £25,000 to create a tribute to that monarch only part of this fountain seems to be dedicated to him – the

51
The Fountain of Sabrina

Gerald Laing

east side of the arch, where a lion mask spouts water, there is the inscription 'IN MEMORY OF KING GEORGE V 1910 – 1936'. On the side facing the river, under the arch that forms a bridge across the pool, are two figures not related to the King or his reign.

One represents a farmer, the other a coal-miner. These were once part of the decoration over the entrance to the headquarters of the Co-operative Wholesale Society, formerly on the site of Broad Quay House. When the old CWS building was being demolished the sculptures were removed and kept in storage.

When Alec French Partnership, the architects of Broad Quay House, were designing a scheme for a landscaped area these figures were remembered and incorporated into the feature. The arch was made the same size as the original arch over the CWS entrance to contain the rescued sculptures.

They had been carved around 1903 and represent the workers for whom the CWS was founded. The Co-Op distributed its profits to its members and 17 stores still trade in Bristol.

The lion mask on the George V side was designed and cast in aluminium by Derek Carr of Timsbury. □

City centre Narrow Quay
Broad Quay House courtyard
1980
A fountain of four bronze figures
 in a granite basin
Owner: Standard Life Assurance

After Gerald Laing completed a large frieze for the Standard Life offices in Edinburgh in 1978 their Property Development Manager, Peter Henwood, asked him to create a sculpture for Broad Quay House, then under construction in Bristol. Henwood believed sculpture could enhance a building out of all proportion to its cost. The Alec French Partnership designed the building and worked with the sculptor.

Although the first proposal was for a relief, similar to the Edinburgh commission, Laing persuaded his client that a fountain in the courtyard would be preferable.

Sabrina appears at the moment of her rebirth from the depths of the river, riding on a shell in the manner of Botticelli's Venus. She was cast by Laing in his own foundry at Kinkell Castle and he wrote generously of the skill of George Mancini, a bronze worker, who came out of retirement to help make this work. The

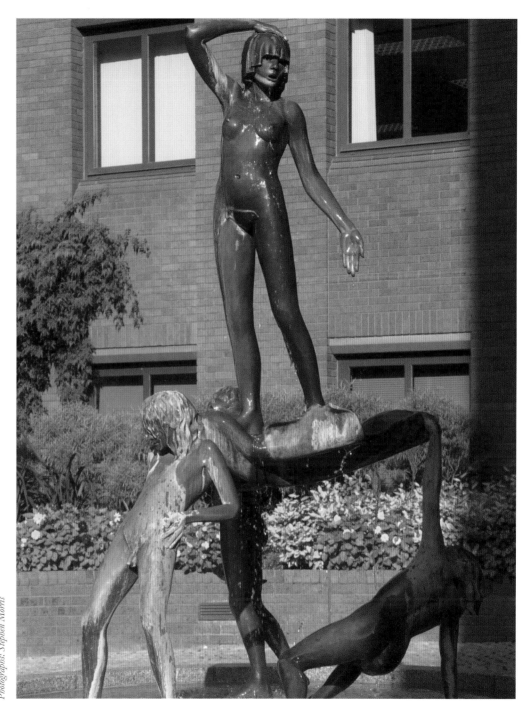

Photographs: Stephen Morris

shell was sand-cast in Inverness and the whole project took about a year.

Contact between the three boys has been kept to a minimum to suggest the idea of flight and forward movement. Water flows from the goddess's head, at a point covered by her right hand, over her body into the shell. It also pours from the head of the boy in the centre to ensure a plentiful overflow of water from six scoops on the shell.

Sabrina, the Roman name for the River Severn, appears in John Milton's masque *Comus*. She was a Romano-British princess who antagonised her mother by living with her lover. After a battle, during which her mother's supporters killed him, Sabrina drowned herself. The god Nereus took pity and transformed her into the goddess of the river, from then called the Sabrina and later to become the Severn.

The front of the fountain has the inscription: 'A metaphor for the triumph of life over death and a subject for contemplation. 1980-1981 GERALD LAING'. □

52
Water Maze

Peter Milner and Jane Norbury

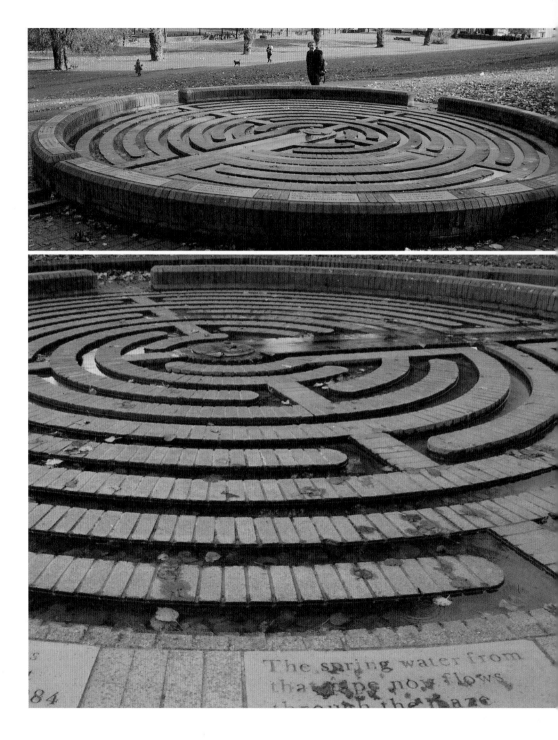

Victoria Park, Windmill Hill
1984
Red bricks and terracotta plaques
Owner: Bristol City Council

Bristol architect and civic planner Mike Jenner wrote in the *Bristol Evening Post* about this unique installation: 'It is a delightful and brilliant idea, beautifully carried out, a constant source of pleasure to small children who float sticks around the convolutions of the channel'.

The Victoria Park maze commemorates <u>two</u> improvements in the supply of water to the city. The first, made in 1190, was a conduit to bring fresh spring-water from Knowle to Redcliffe. Robert de Berkeley paid for this pipe and there is an inscription outside St Mary Redcliffe marking the point where the water emerged. The spring still flows 800 years later.

The second improvement was a huge main sewer built by Wessex Water in 1984 as part of the sanitation system for the city and this follows part of the old conduit route.

Serendipity inspired the designers. The maze pattern they chose is a precise copy of a roof boss in the north aisle of St Mary Redcliffe. Carved in the late fourteenth-century the boss is identical to a maze in the nave of Chartres Cathedral – also dedicated to St Mary.

By chance, this is a continuous line maze – the only type that allows water to flow through without interruption. The perimeter of the

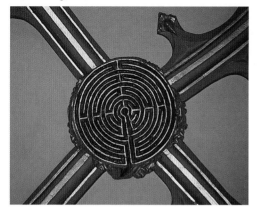

This maze forms a gilded boss in St Mary Redcliffe

water maze, approximately 19 metres long, has 25 ceramic plaques to tell the history of water supply and its effect on public health: from the early conduit, deaths from cholera epidemics in 1832 and 1849, to new sewers in the 1850s and recent water improvements.

During the construction of the maze the old pipeline was uncovered and found to be in good condition as far as the railway bridge in St Luke's Road. Beyond that point Second World War bombs had damaged the ancient pipe. □

53
Hand of the River God

Vincent Woropay

Baltic Wharf
Outside Westbrooke Court
1986
Bronze on a limestone pedestal
Owner: Bristol City Council

The sculptor's name appears in tiny lettering on the casting but, like far too many works in public, the evocative title of the work is not displayed. We are deprived of any clue to the thinking of the artist and the intention of the work – in this case a symbol of a god directing or blessing the river under his protection. Sculptures and paintings in galleries have titles and information about them. Why do public sculptures so often fail to tell us the title – a guide to what the work represents?

The huge bronze hand gains attention from many passers-by. A figure of Hercules struggles to lift an obelisk. This part of the sculpture, designed as a fountain, is set between the giant fingers and thumb – and that certainly gained *someone's* attention. Regrettably this fragment was stolen at the end of 1998, leaving the sculpture's message even more mysterious. So far it has not been traced. Perhaps it now adorns a garden?

Vincent Woropay based this part of his sculpture on a sketch made by the Italian architect and sculptor Gianlorenzo Bernini (1598-1680). Bernini's drawing of Hercules was a suggestion for a monument in the Piazza Santa Maria sopra Minerva (1666) in Rome.

The drawing by the Renaissance sculptor Bernini on which Vincent Woropay based his design.

Hand of the River God / continued

This design was not used. The monument in the piazza is in the form of an elephant, with an obelisk on its back.

Woropay's bronze is one of three sculptures erected on Baltic Wharf as part of the 'Percentage for Art' policy. That system required the developers to spend a small proportion of the building costs on public art. The other sculptures on Baltic Wharf are *Atyeo* (page 120) and *Topsail* (page 121). □

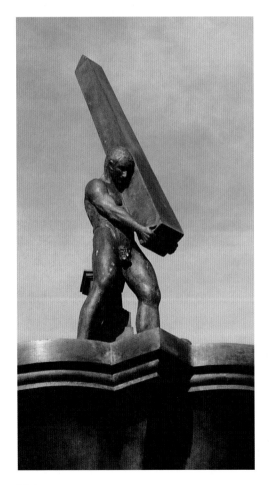

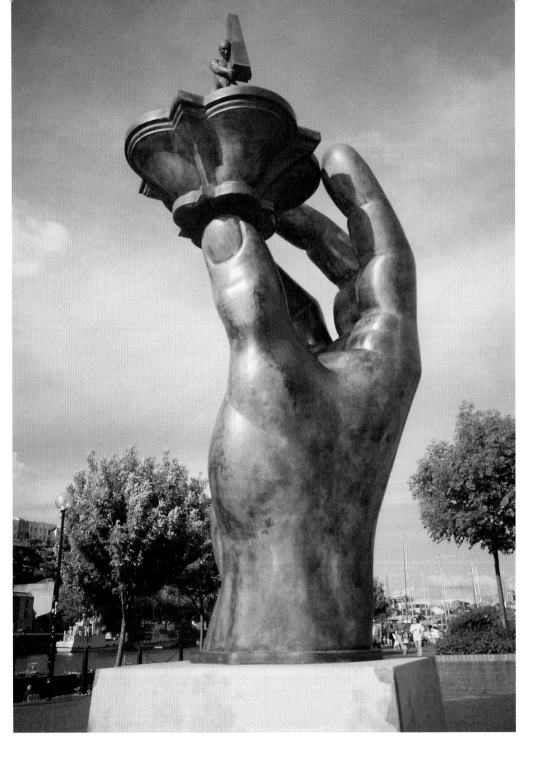

54
Exploration

Philippa Threlfall, Kennedy Collings and James Blunt

City centre
Redcliffe Quay Piazza
1991
Obelisk: Stones and ceramic surface with a
stainless and painted steel armillary sphere
Owner: Standard Life Assurance

The whole sculpture is called *Exploration*, referring to the fifteenth-century mariners who sailed from Bristol's docks to cross unexplored oceans. The obelisk has the title *The Unknown Deep* and this was designed to have water running down the four faces. However, after trials this was found inadvisable and the supply was disconnected. Surfaces were painted with a sealing coat to give a 'wet-look' to the mosaic of undersea monsters and serpents, composed of stones gathered from beaches and riverbeds in the west of England.

The artists based these creatures on medieval bestiaries and drawings, some of them found in the Chained Library of Wells Cathedral. The sides of the obelisk record the early belief that there were aquatic versions of land-based animals. Sea-tigers, deer, hounds and wolves can be found.

Before the building of this office block commenced there was an archaeological investigation of the site. This revealed seeds and other material that, after analysis, enabled researchers to discover what cargoes had been brought to Bristol centuries ago and from what

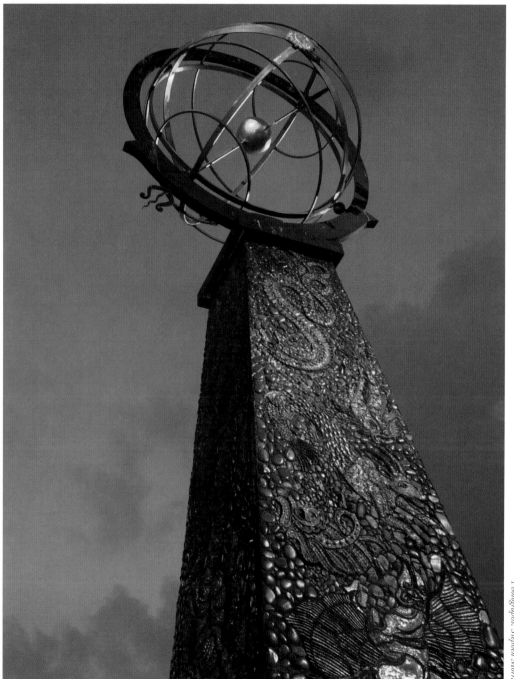

Photograph: Stephen Morris

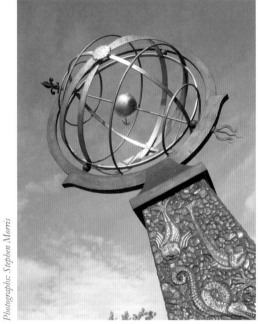

Photographs: Stephen Morris

part of the world these ships had come. The armillary sphere, a device used by early astronomers to determine the position of the stars, was designed and made by James Blunt, and this does function as a sundial. The time can be read on the inside of the equatorial ring that relates to the latitude of Redcliffe Quay.

Other work in Bristol by Philippa Threlfall and Kennedy Collings includes historical reliefs on both Broad Quay House and Colston House in Colston Street. □

55
Beside the Still Waters

Peter Randall-Page

Castle Park
at the east end of St Peter's Church
1993
Two carved forms in Kilkenny limestone
Owner: Bristol City Council

A flowing water channel, paved and bordered
in an avenue of lime trees, is aligned with the
nave of the ruins of the church.

Two forms, each set in a circular pond, are
carved into organic forms that have been the
basis of Randall-Page's work for many years.
One form has the appearance of a pine cone;
the other terminates in five hollows from
which the water flows.

This installation, part of the Castle Park
scheme of the mid-1980s, was designed by the
sculptor in collaboration with Bristol City
Council's landscape architects and was
described by the local press as 'an oasis in the
heart of the city'.

Norwich Union, the developers of the
Galleries shopping centre, contributed to the
cost and there was an appeal to raise the final
amount. Randall-Page held an exhibition at the
Arnolfini in September and October, just
before the appeal in 1992. □

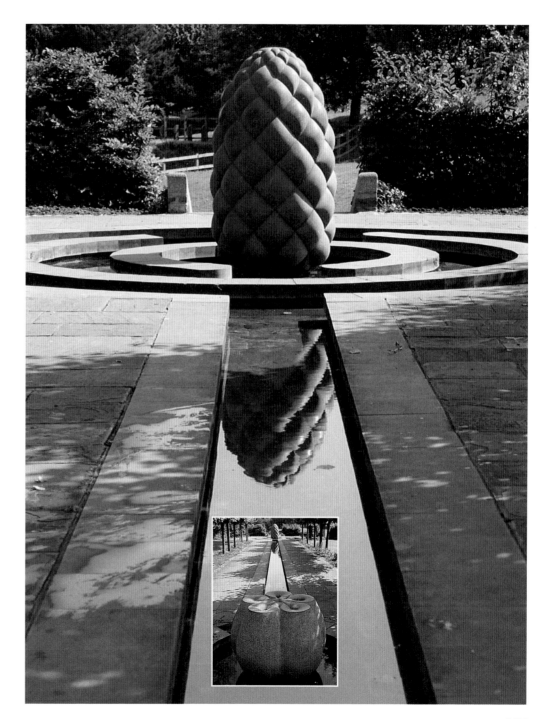

56
Fish

Kate Malone

Castle Park
1993
Bronze fountain with brick and terracotta tiles
Owner: Bristol City Council

Orange juice and red wine spurted from the two fish mouths on the day this drinking fountain was unveiled by Jerry Hicks, the Chairman of the Bristol Civic Society. That expansive gesture was short-lived but Kate Malone's creation still flows with images to amuse and inform. There are boats, castles, tobacco leaves, hot-air balloons, coins, the head of the black angel from the tomb of Scipio Africanus – a black servant who had been a slave and is buried in Henbury churchyard. These and dozens of other clues to the life of Bristol cover the sculptured fountain and the decorated base in child-like profusion.

The sculptor gained the commission, like other artists in the Castle Park scheme, through winning a limited competition.
She has donated her original ceramic version to the Bristol Museum and Art Gallery. This began as a large coiled vessel with cast clay reliefs that were applied before being fired. Brightly coloured glazes evoke the sea. The Pangolin Foundry, in Stroud, cast the bronze version for the park from the ceramic version, using the lost wax (*cire perdue*) process.

The fountain is close to the cycle path and the sculptor hoped this would be a boon to exhausted cyclists and walkers. ☐

57
Aquarena

William Pye

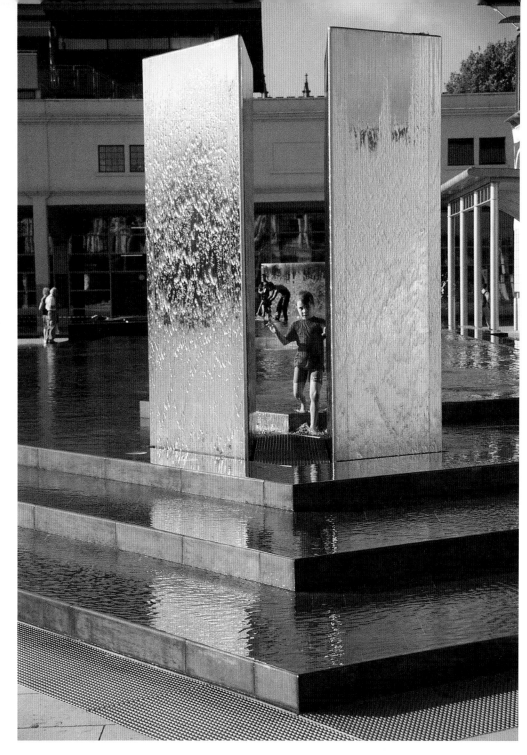

Canon's Marsh
Millennium Square
2000
Stainless steel and black marble
Owner: (at) *Bristol*

Fountains, pools and water features enliven
urban spaces in all parts of the world. They
form meeting places – from the Trevi Fountain
in Rome to modest parish-pumps.

Pye's large sculpture makes a dramatic entry
to Millennium Square and *Aquarena* has already
become a focal point. As its name suggests, the
space can be adapted for live performances.
Whatever the intentions of the sculptor,
dozens of children already enjoy themselves
with water and its reflections.

There are several elements. Curved, stainless
steel walls, shimmering under sheets of falling

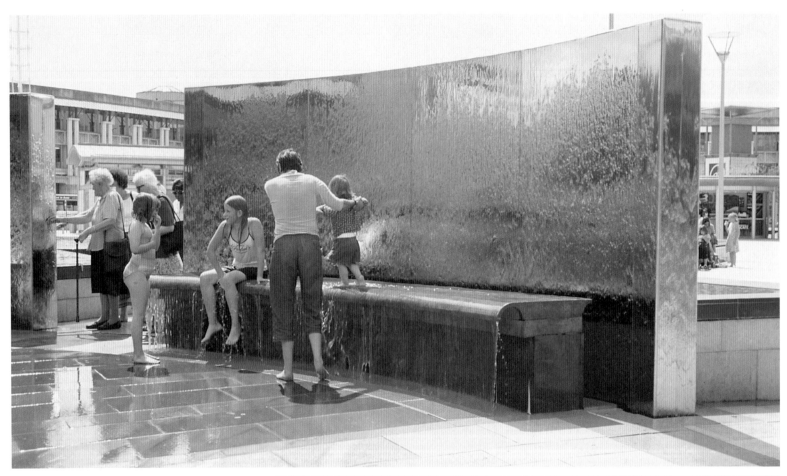

Aquarena/ continued

water, rise from black marble areas covered with very shallow water. At intervals, rows of jets throw up a tunnel of water through which children love to run. Lighting has been installed to enhance the sculpture at night.

Aquarena is one of the most ambitious installations that William Pye has made in over 30 years of developing his ideas for sculpture based on the behaviour of water. □

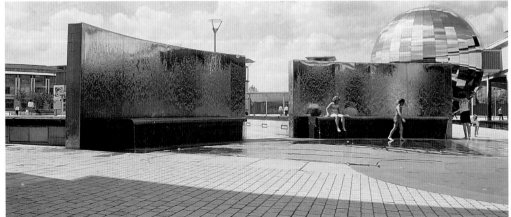

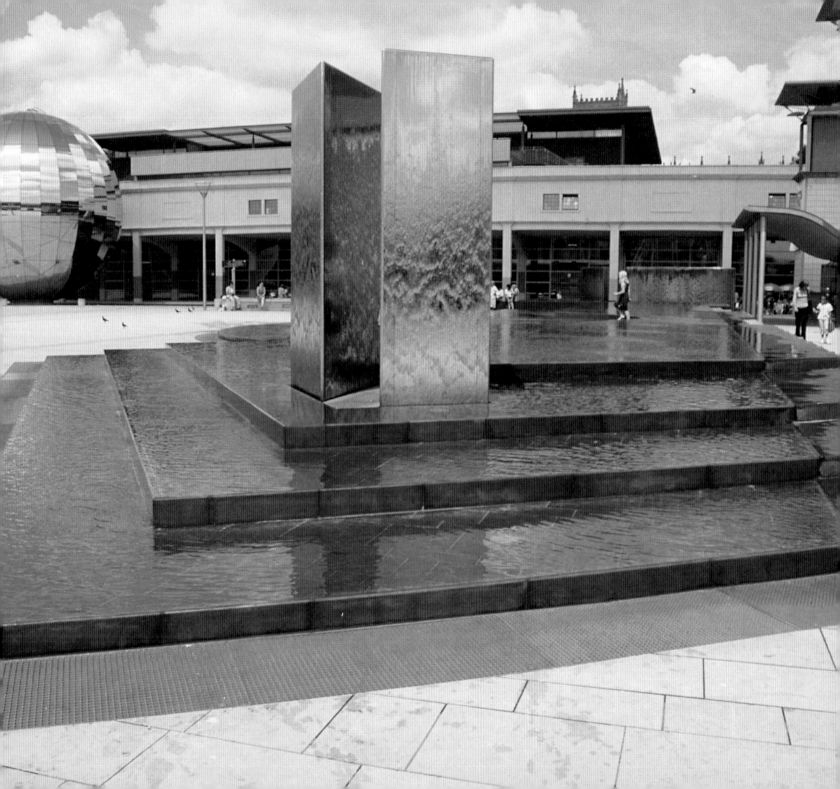

Modern sculptures

58
Spirit of Bristol

Paul Mount

Haymarket, St James' Barton
1971
Stainless steel

'New and startlingly modern', 'controversial' and 'a few eyebrows were raised'. These were typical quotes in the Bristol press when this 5.4-metre sculpture first made its appearance close to the central shopping area of Broadmead.

One account said the work attempted to express Bristol's two major industries with references to sails of the maritime past and aerodynamic shapes of the present. Concorde's maiden flight in Britain had been made at Filton in April 1969.

The *Spirit of Bristol*, commissioned by Copthall Holdings and Bristol Corporation, made a strong impression when it was erected. As the years passed, in spite of its size, the sculpture has been enveloped in the trees and shrubs planted around its base. By 1986 the *Evening Post* called it the 'Vanishing Spirit – subdued by vegetation'. A more prominent site and lighting, high above the Broadmead roundabout, would give new life to a work that is already a rare echo of its time. □

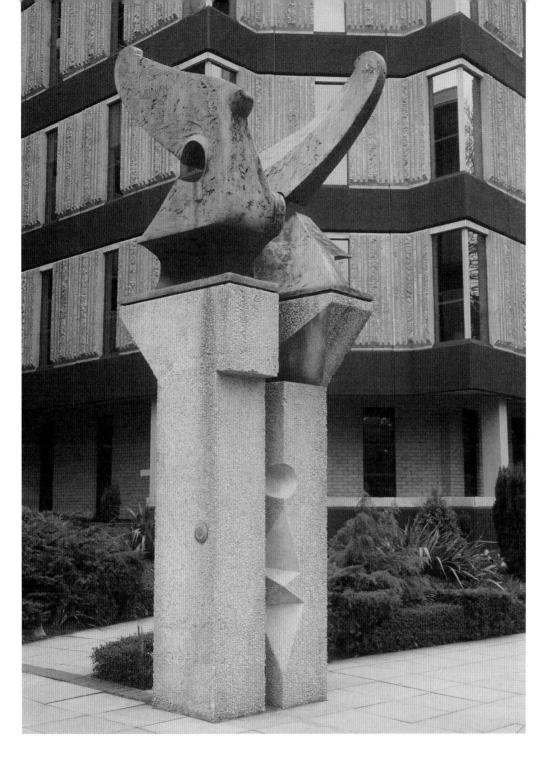

59
Oracle

Franta Belsky

Temple Way House Narrow Plain
1975
Aluminium-filled polyester resin on a concrete column
Owner: Clerical Medical Investment Group

Reporting on this sculpture in 1977 the *Architectural Review* said, 'Unlike America or France large-scale sculpture in public places is still a rarity in England'. The writer of the article praised the late Franta Belsky as one of the few sculptors in this country to have consistently accepted major public commissions and described this work as 'two balancing forms of Delphic inspiration'. *Oracle* was awarded the Sir Otto Beit Medal by the Royal Society of British Sculptors in 1976.

 The construction of Temple Way House led to this commission and Belsky's brief was to design 'a temple guardian' in the form of a fountain with water running on the pillars into a pool.

 Belsky pioneered the use of lightweight resins, a technique that enables sculptors to cast their own work and by-pass the traditional bronze foundry. His first sculpture to use this material was *Triga* – three massive horses on Caltex House, Knightsbridge, made in 1959. □

60
Horse and Man

Stephen Joyce

City centre
St George's Road, courtyard of Brunel House
1984
Resin and bronze Life-size
Owner: Bristol City Council

Why were a horse and man chosen for this tranquil and out-of-the-way setting? Now an office complex, the area had been a horse market in nineteenth-century Bristol.

Brunel House was originally The Royal Western Hotel, built in 1837 by the Bristol architect Richard Shackleton Pope in collaboration with Isambard Kingdom Brunel, for passengers on their way from Temple Meads Station to board the *Great Western* steamship for America. To the east of the hotel was a covered area, where coach passengers could alight in all weathers, called the 'Bazaar Ride'. When Bristol's transatlantic trade foundered the area first became the city's most important horse-dealing centre, then languished as a car park.

Few Bristolians know the sculpture and strangers would be unlikely to find this very pleasant site.

The work is by local sculptor Stephen Joyce who has many other works in the city. He has made the man small, with large piercing eyes and he wears a peaked cloth cap. His clothes are those of a labourer in the late nineteenth or

early twentieth century. The paving around the sculpture is a herringbone pattern of bricks. Three steps lead to a grassed arena formed by the remains of the original building. The horse is being led towards the entrance of the courtyard. The harness is almost conceptual. Two straps lead toward, but they do not reach, the horse's body. The two life-size figures were freely modelled in clay and then were cold cast in a mix of 50% bronze and 50% resin.

The original building survived threats of demolition until a £6-million redevelopment, funded by the Co-operative Insurance Society, was completed in 1984. Only Brunel's façade and pavilions were retained.

ACCES* and the architects, Alec French Partnership, commissioned the sculpture. When the Lord Mayor of Bristol unveiled the work in the presence of the sculptor and the architect on 21 August 1984 there were plans to use the space for open-air performances in summertime, with seating for 200 people. □

* Avon County Community Environmental Service

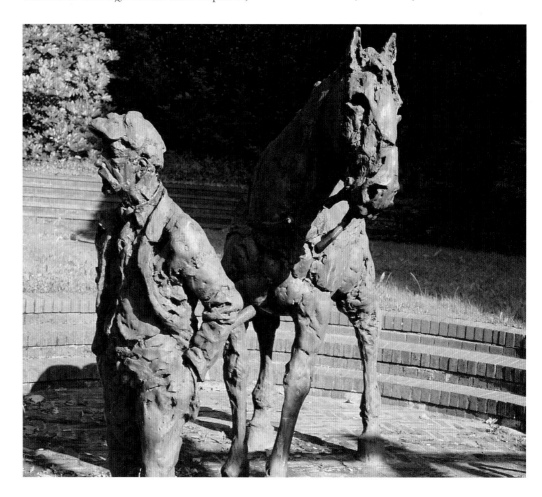

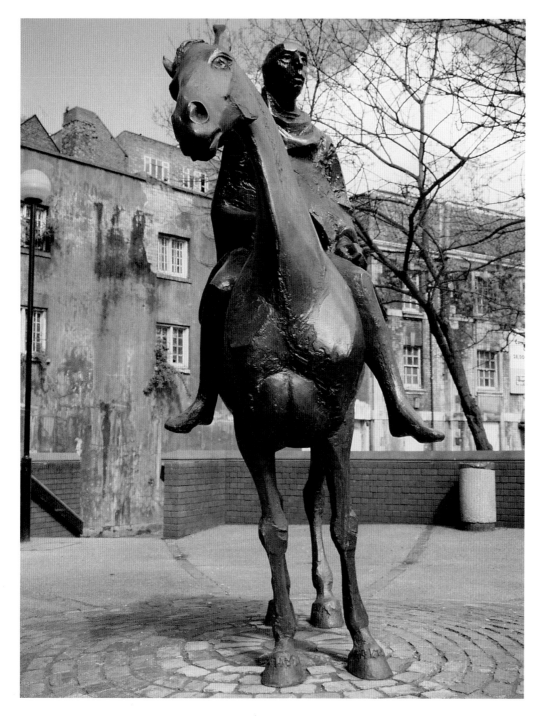

61
Cloaked Horseman

David Backhouse

City centre, Lewins Mead
Narrow Lewins Mead, on the forecourt
of St Bartholomew's office development
Bronze
1984
Owner: Bristol City Council

This equestrian statue was commissioned by Haslemere Estates and presented to the City of Bristol in 1984.

Horse and rider are in the centre of a slightly domed circular area. The rider is bareheaded, without stirrups, bridle or saddle. His hands are placed as if he is holding the rein. He gazes towards St John's Gate that was part of the ancient city wall at the bottom of Broad Street. The sculptor imagined the horseman ready to enter the city. Before the site was developed an archaeological investigation revealed part of a thirteenth-century bridge that once crossed the Frome. The river still flows beneath the road. St Bartholomew's Hospital (founded c.1220) cared for travellers, and possibly lepers, on this site for over three hundred years – until 1532 when Bristol Grammar School used the site. Queen Elizabeth School took over in 1766 and stayed until the mid-nineteenth century. The site was then used by various industries.

Backhouse made four maquettes before one was selected, enlarged to a full-size plaster model in his studio at Bradford-on-Avon and then cast in bronze at the Burghleighfield Foundry in High Wycombe. □

62
The Creation

Walter Ritchie

City centre
Bristol Eye Hospital
Lower Maudlin Street
1986
Ibstock Bricks
Owner: Bristol Eye Hospital and the United Bristol
Healthcare NHS Trust

When installed, these Bristol panels were the largest non-reinforced brick reliefs ever carved. They total just over 18 metres in length and the commission took three years to construct.

Although he worked and experimented with many materials – steel, aluminium, stone, marble and wood – Walter Ritchie's most innovatory and distinctive work was in brick.

Five panels of hand-carved bricks form a screen in the wall outside the entrance to the Eye Hospital that was designed by the architects Kendall Kingscott.

One panel depicts the origins of the earth with the elements in full force. The next is filled with seeds and flowers. Mammals and reptiles in another panel lead on to birds in flight and shoals of fish. The final panel represents humanity, a mother and child, and displays the text that was the artist's original inspiration – a cutting from *The Times* quoting a 1947 lecture on 'Creative Man' that was given in Oxford by Viscount Samuel.

Surprisingly, the panels were not constructed on site in Bristol. All five were built as separate walls and the bricks were shaped in Ritchie's home in Kenilworth, Warwickshire.

Each relief is composed of two sections and these, all 1.6 by 3.6 metres, had to be delivered by lorry to Bristol.

One of his last major public sculptures, made in 1993, is a brick relief of Sir Leonard Hutton at the Oval cricket ground.

From early in his career Ritchie sought commissions for public art and the art critic Sir Herbert Read helped him in this aim. Streets rather than art galleries were his realm. □

63
Atyeo

Stephen Cox

Baltic Wharf
facing the river between John Cabot Court
and Portland Court
1986
Verona marble
Owner: Bristol City Council

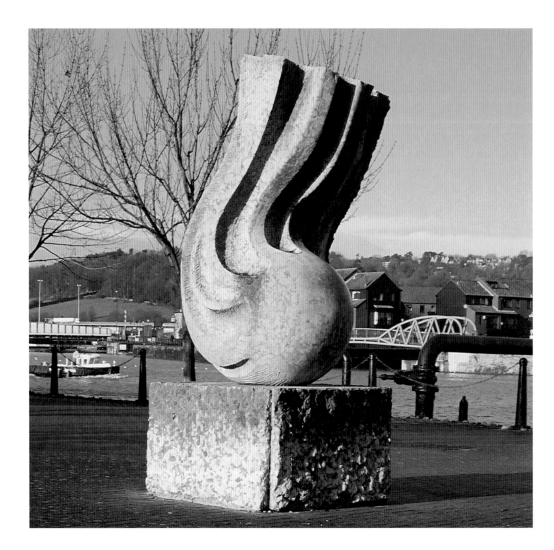

This sculpture was carved from a single block of red Verona marble weighing about three-quarters of a ton. The cost of the work included quarrying the chosen piece of marble and transporting it from Italy where the sculptor has lived and worked.

A press release for the unveiling said, 'The castellated area signifies the city of Bristol sitting on the round base of the globe with which it has historically traded.' At one time there was a plaque that named the sponsors, the sculptor and the title – *Atyeo*. Bristol-born Stephen Cox described John Atyeo, the Bristol City footballer, as 'a hero of his youth'.

When the Rendell Partnership and two housing associations created the Baltic Wharf private development they commissioned three sculptures. These were then given to the city. The other two works on the riverside are *Hand of a River God* (page 103) and *Topsail* (page 121).

The commissioning process was organised by Lesley Greene of the Public Art Development Trust Limited on behalf of the consortium that funded the sculpture scheme with assistance from South West Arts. Sculptors were selected after a limited competition and they had to provide budget proposals for making, transporting and erecting their work on site.

A simple line drawing by Stephen Cox was made into a maquette for the judging panel. He referred them to a sculpture by him, called *Palanzana*, commissioned for the Festival Gardens in Liverpool in 1984. He wanted the smooth globe to remain accessible as hand contact would serve to polish the form. After 15 years this marble carving enlivens the harbour-side and people may be seen indulging in this tactile play.

Non-representational sculpture of this kind enables newspapers to make witty remarks when unveiled. They sunk to the occasion in 1985 with 'Is it a fishtail? Is it a shoe? No, it's a – well it's symbolic.' □

64
Topsail

Keir Smith

Baltic Wharf
facing the river by Westbrooke Court
1987
Portland stone
Owner: Bristol City Council

Originally there were to be four sites in the Baltic Wharf scheme. The theme of the limited competition was 'Maritime Bristol'.

In his submission to the judges Keir Smith said he wished to carve as much as possible of the design on site, although the roughing out would have to be carried out with power tools. He had found that local communities reacted very positively when they saw a sculpture being made and in this case he was able spend six weeks carving much of his design on-site.

Topsail was an early work in a very productive career and it was one of three public sculptures commissioned for the Baltic Wharf housing project. The other two are on pages 103 and 120.

Keir Smith conducted a great deal of research hoping to find a local Bristol stone in which to carve the work but he finally selected a seven-ton block of the renowned Portland stone, ideal for architectural sculpture, due to its extreme hardness and weather-resistance. There are minimum overhangs and undercuts to alleviate the problems of vandalism.

His presentation drawing, reproduced here, was sent with his proposals to the competition judges in 1985. □

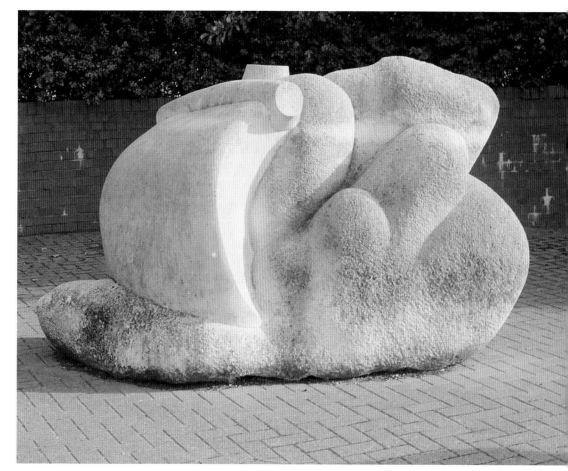

65
Throne

Rachel Fenner

Castle Park
to the north side of St. Peter's Church
1993
Normandy limestone
Owner: Bristol City Council

Rachel Fenner has appropriately carved her sculpture in Normandy stone to connect this work to the history of the site. The park takes its name from the Norman occupation and the remains of the original castle – an important base built by the invaders in the twelfth century. Bristol City Council commissioned work from over 20 artists when Castle Park was being developed in the early 1990s.

A cube of hard stone is minimally carved to suggest a once soft seat with the impression of an absent hand in the right-arm of the vacant throne. A ghostly footprint appears in the base. The folds of a robe are used to form the seat and the shape of a leg is pressed into the lower part, while a discarded robe is draped over the left side.

All this invites the viewer to usurp the place of the absent ruler – and many visitors to the Park do this, some photographing the occasion of their enthronement. Rachel Fenner's intention was to prompt viewers to recall those Norman conquerors who affected our history in so many ways. □

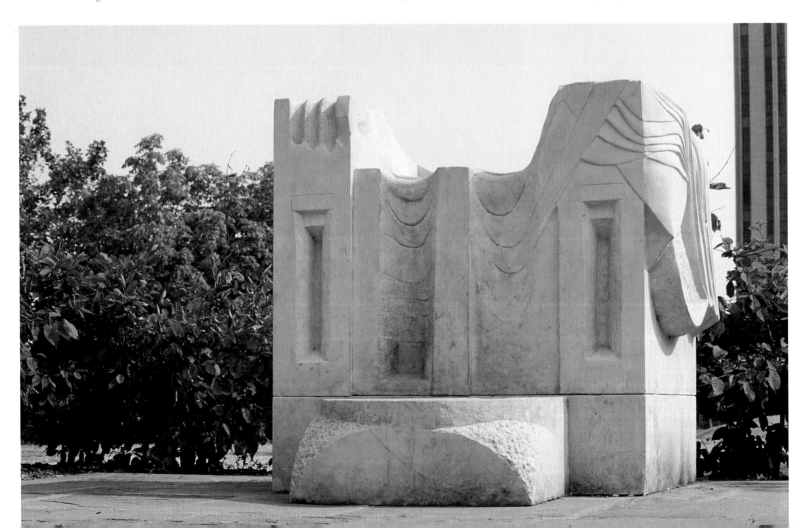

66
Line from within

Ann Christopher RA

Castle Park
1993
Sand-cast and patinated bronze
Owner: Royal West of England Academy

The overall brief for all the sculpture commissioned for the re-modelled Castle Park area – almost destroyed during the Second World War – was to reflect the history of the site. Ann Christopher's 4.5-metre high bronze was the last of these to be erected. The work was sand-cast by the Pangolin Foundry at Stroud and finished by Ken Cook.

She chose a site that is now one of the busiest entrances to the park and marked this with flat rectangular shapes suggesting a castle gate rising from the hidden foundations of the ancient city beneath.

The Royal West of England Academy commissioned her work through funds from the Talboys Bequest and it is now on permanent loan to the City.

In an introduction to an exhibition of Ann Christopher's sculpture in 1994 Sir Hugh Casson said her work showed a 'sophisticated choice of surface textures interrupted occasionally by a controlled vertical cut or fine-edged aperture'.

Ann Christopher has a public sculpture in London near Tower Bridge. She is a member of the Royal Academy – her studio is in the West Country, near Chippenham. □

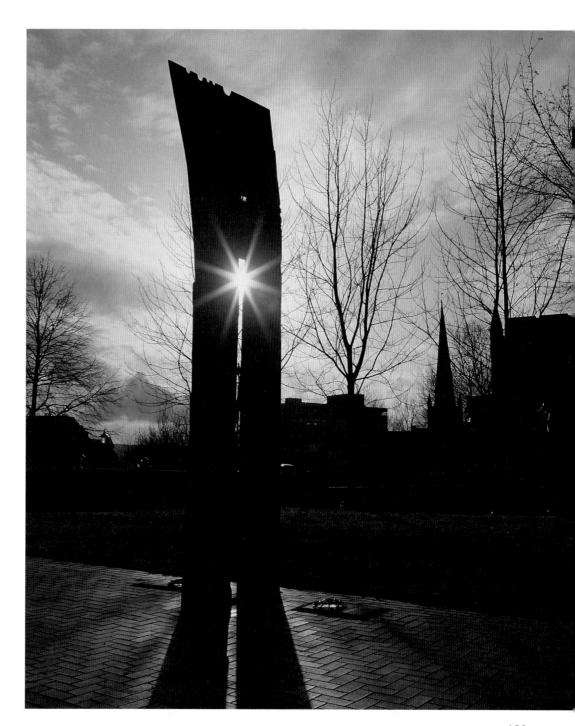

67
Beetle

Nicola Hicks

Canon's Marsh Anchor Square
2000
Bronze on a limestone pedestal
Owner: @ *Bristol*

This work was part of a major public sculpture programme, commissioned to complement the science installations, Explore, Wildwalk and the newly designed areas on Canon's Marsh. The themes set for the sculptors were reflection and exploration.

Here a huge beetle confronts us very dramatically. Children are immediately in awe. Nearly two metres long on a simple low stone pedestal, it can readily be touched and, as intended, this attracts much attention.

The large insect is based on the rhinoceros beetle, one of various scarabaeid beetles that have one or more horns on their heads. This is one of the world's strongest creatures. It can support up to 850 times its own weight and one of the species is a feared pest on coconut plantations. An actual-size model can be seen inside Wildwalk.

Nicola Hicks specialises in drawing and sculpting animals and on this occasion she modelled her giant insect in plaster and straw and then The Bronze Age Foundry in London made the bronze cast. □

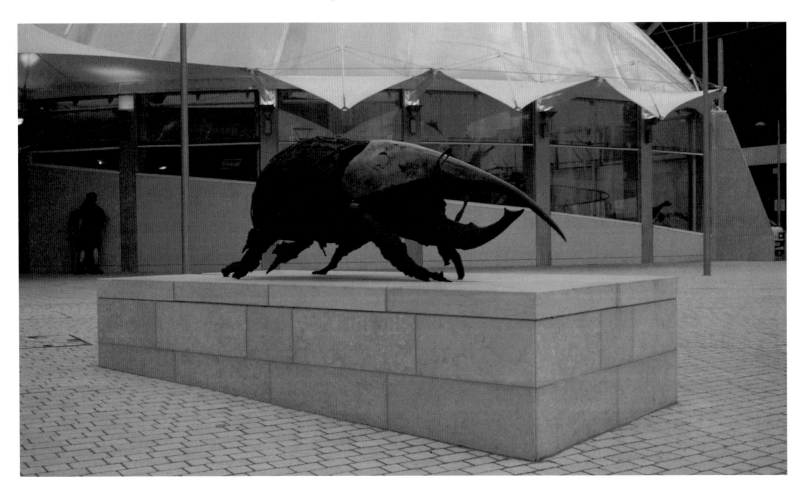

68
Jasmine and Bill and Bob

Cathie Pilkington

Canon's Marsh
On Anchor Road and the south-east
corner of Millennium Square
2000
Painted bronze
Owner: @ *Bristol*

Cathie Pilkington's sculptures defy a conventional perception of public sculpture – bronze statues of unknown men on pedestals. They are life-size, realistic Jack Russell terriers, convincing enough to deceive many passers-by.

In this, her first commission for a public space, she wished to create something small and ordinary that 'might get overlooked'. *Jasmine* has not been overlooked. She attracted so much attention she was stolen but happily, recovered and after repair she will be re-sited inside one of the @ Bristol buildings.

With humour and illusion the sculptor has involved her audience. *Jasmine,* with her trailing lead, appears abandoned. Or is she waiting for her owner? Bill and Bob wallow in a puddle, to the delight of children, by a car park entrance.

Another naturalistic dog has joined this canine trio. A Bristolian scenic artist, named Mark Barraud, owned a terrier called Nipper, that was born in Bristol in 1884. This dog became the HMV trademark about a century ago and it has recently been commemorated on a University of Bristol building in Park Row. □

69
Zenith

David Ward

Canon's Marsh Millennium Square
2000
52 runway landing-lights
Owner: (at) *Bristol*

There is one light point for every week of the year. These are set into the surface of Millennium Square and form an elongated figure of eight, or the sign for infinity. David Ward's concept is based on an analemma – the line traced by the sun when recorded at noon, its zenith, over the course of a year. In the past, navigators and explorers plotted the height of the sun at noon, using a quadrant, to determine the latitude in which they were travelling.

A computer programme controls the lights to trace a constantly changing sequence of free-flowing patterns. David Ward worked with the lighting designer Chris Baldwin, of ACT Consultant Services of Cambridge, in this installation. The lighting units are of the type used in heliports to produce an intense beam for long-distance visibility. Those at the furthest point north mark the highest position of the sun in midsummer.

The themes for commissions in Millennium Square were 'reflection' and 'exploration'. Here the designer's aim was to suggest broad associations with astronomy and the progress of the earth around the sun. In this he wished to evoke ideas about time and space rather than to make a literal or scientific model. □

Photography: Jack Tait

70
Lollipop Be-bop

Andrew Smith

Bristol Royal Hospital for Children
Upper Maudlin Street
2001
Stainless steel and optic fibre lighting
Owner: The United Bristol Health Care Trust

Children in the hospital will be able to play with the lighting sequence of this new sculpture that has the appearance of a child's gigantic toy.

From the lift lobby on Level 3, high above the street, young patients will set up their own order of lighting and control the system by pressing buttons on a console.

The sculptor won this commission in a nation-wide open competition. He sought a solution that would allow children to participate in the work and he was able to achieve this in an unusual way in collaboration with structural engineers Benson-Sedgewick and with the lighting designers Hoare Lee.

Lesley Greene, who was the Director of the Public Art Development Trust at the time of the Baltic Wharf and Castle Park projects, was also the co-ordinator for this work and all the other art installations in the new hospital.

There are 24 works by artists on the site – so many that a catalogue is being produced to present them all. Among them are an interactive work by Aardman Animations and a 'Dolphin' clock by Kit Williams – both in the main reception.

Lesley Greene said Andrew Smith's design was chosen because it was immediately recognisable, memorable, and very welcoming. The architect of the new building, David Radford, of the Bristol architects Whicheloe

Macfarlane MDP, felt this exuberant work was just what he wanted to complete the exterior.

Patients, hospital staff and well-wishers took part in the inauguration ceremony on the evening of 1 November 2001.

Funding for the project came from a Grand Appeal that was able to raise a million pounds for the hospital's arts programme generously supported by private and commercial sources. This included £218,500 contributed from the National Lottery through the Arts Council. □

Sculptors and designers

Designers and craftsmen
from many countries have created
the city's sculpture for centuries.

Their skills have ranged from stonemasonry
to the use of fibre optics.

The page numbers on which
the sculptures appear are given
in bold type at the end of each entry.

Abbreviations

ARA	Associate Member of the Royal Academy
ARBS	Associate of the Royal Society of British Sculptors
fl.	Flourished
FRBS	Fellow of the Royal Society of British Sculptors
RA	Member of the Royal Academy
RCA	Royal College of Art
RWA	Royal West of England Academy

Barbara Ash MA RCA (1966-) After gaining her BA at Middlesex University Barbara went on a post-graduate course in Cyprus. She then spent two years at the RCA including an exchange to Lisbon College of Art. She has just completed a year as an Artist-in-Residence at a special needs school, in London, where she made a set of reliefs. In February 1995 she travelled to Moscow to make work for the International Ice and Snow Festival. In 1992 she was awarded a Henry Moore Fellowship in Sculpture at Canterbury College of Art. At present her studio/workshop is at the Bristol Sculpture Shed at Spike Island Artspace. Page **92**

David Backhouse RWA (1941-) In the past 20 years Backhouse has undertaken a large number of sculptural commissions for public sites. Many of these are in London – *Dolphin Family* in Docklands, *Dance of the Centaurs* at Whiteleys in Bayswater – and *Flying Figurehead* was created for Sainsbury's in Cardiff. In Bath he has a statue of *The Young Mozart* and he designed the Merchant Navy Memorial now on Welsh Back in Bristol. His list of portrait commissions is long and varied. They include The Marquess of Bath, José Carreras, Bishop Henderson of Bath and Wells, and Sir Colin Davis. David Backhouse lives in the West Country. Page **117**

Edward Hodges Baily RA (1788-1867) was born in Bristol but he spent most of his long life in London and died at Holloway, north London. His father was described as 'a ship's carver and a man of considerable artistic talent'. Bristol Cathedral sculptures inspired Baily when he was young and he experimented by making portraits in wax. A local surgeon supported him and introduced him to John Flaxman (see page **22**) and when Baily was only 14 he went to London as his pupil. His list of work in the *Dictionary of British Sculptors* shows he was among the most prolific sculptors of the nineteenth century. He made a large amount of money but his last years were so difficult he applied to the Royal Academy for assistance when he was 70. Other work in Bristol: *Eve at the Fountain* (1818) in the Museum and Art Gallery and *Justice* (1827) on the Old Council House in Corn Street. Page **76**

Franta Belsky FRBS (1921-1999) was born in Brno, Czechoslovakia. Like many of his generation his education was wide but interrupted. He first studied at the Academy of Fine Arts in Prague before fighting in France in 1940 and he took part in the Normandy landings. He studied sculpture at the RCA and became President of the Society of Portrait Sculptors. His other major works include:

the *Paratroop Memorial* in Prague (1947), a statue of Cecil Rhodes in Bulawayo (1953), the fountains at the Shell Centre on the South Bank (1961) and the Arndale Shopping Centre in Manchester (1978). He was married to Margaret Owen, the well-known cartoonist who signed her work 'Belsky'. Page **115**

Judith Bluck FRBS (1936-) worked as an engraver, a designer and a painter before finding her métier as a sculptor. Her large-scale works have taken many forms and used a variety of materials. A 24-metre brick relief, *The Legend of the Iron Gates*, made for Sainsbury's site at Wilmslow won the Otto Beit Medal of the RBS. She has sculpture in Portsmouth, at Brooklands, Surrey, Ealing, Marlow, and at the Central Library in Dunedin, New Zealand. Her work has been exhibited in this country, France and the USA and she holds the Bronze and Silver Medals of the Société des Artistes Français. Page **48**

Sir Edgar Joseph Boehm (1834-1890) Hungarian by descent but Austrian by birth and education, he came to England, via study in Paris, at the age of 28 to become one of the most prolific and successful sculptors of the late nineteenth century. His biographer, Mark Stocker, said, 'To the Royal family, his naturalistic style simply made a change from the dreary English neo-classicism – he possessed technical training to suggest in marble the differences between flesh and fabric, fur, jewels and metal.' His studio in The Avenue, Fulham, was a hub of the Victorian art world through which passed Whistler, Burne-Jones, Lord Leighton, and Millais. Other major works are – *Drake* at Plymouth and Tavistock, *Queen Victoria* at Windsor and *Tyndale* on the Embankment, London. He believed his best work was the statue of Thomas Carlyle in the National Portrait Gallery of Scotland. Queen Victoria's daughter, Princess Louise, was one of his pupils. Page **25**

James George Bubb (1782-1835) attended the Royal Academy Schools where he won a Silver Medal aged 23. In 1806 he gained a commission for a monument to Pitt to be erected in the Guildhall in London but was accused of estimating vastly less than any other competitor. More reprehensibly, he was said to have given cards to the judging committee, Members of the Common Council, on which he showed the mark he put on his model. He exhibited at the RA from 1805 to 1831. Page **71**

John Cassidy FRBS (1860-1939) was born in County Meath. He left Ireland to study at the Manchester School of Art where he won national medals and other prizes. He began to work professionally in 1887. In 1911 he had a studio in Plymouth Grove, Manchester and wrote from there to the Lord Mayor of Bristol. He mentioned his Colston statue (1895) and asked for his name to be put on the list of sculptors some months before the competition for the King Edward VII Memorial was announced. He took part but was unsuccessful. He made a statue of Queen Victoria for Belfast, and other public statues for Aberdeen, Bolton, London, and Manchester. He died in Cheshire. Page **30**

Hermon Cawthra ARCA FRBS (1886-1973) was born in London but studied at art schools in Shipley (1904) and Leeds (1907-11) before entering the RCA and the RA Schools. He exhibited at the RA and worked in London making many memorials and monuments in wood, stone and bronze. Page **86**

Ann Christopher RA RWA FRBS (1947-) Born in Watford, Hertfordshire, Ann Christopher first studied at Harrow School of Art. Between 1966-69 she came to what was then the West of England College of Art and there she studied under Ralph Brown and Robert Clatworthy. Among a number of other awards she won the Harrison-Cowley

Sculpture Award in 1968 and in 1971 the *Daily Telegraph* Young Sculptors' Competition. She lives and works in the West Country. In 1994 she gained the RBS Silver Medal for Sculpture of Outstanding Merit. Since 1993 she has had commissions for sites in Washington DC, Plymouth, Silk Street, London, St Peter's Hospice, Bristol and Portishead. Page **123**

Stephen Cox (1946-) was born in Bristol and began his art studies there before attending Loughborough and the Central School of Art in London. He had his first exhibition at the Lisson Gallery in 1976. In 1983 he exhibited at the Serpentine Gallery and by 1986 he had a one-man exhibition at the Tate Gallery in London. For many years he has spent much of his time living in Italy and working in marble and stone carving. Page **120**

John Doubleday (1947-) Born in Essex. Before he studied at Carlisle School of Art, and later Goldsmith's College of Art, John Doubleday spent a period living in Paris and drawing in the Musée Bourdelle. In 1975 he had his first one-man exhibition in Wolverhampton. His statue of Charles Chaplin is in the centre of Leicester Square and in the South West he has a memorial at the Royal Marine base in Lympstone, Devon. Page **50**

Susan Dring (1952-) was born and bred in Bristol and she comes from a long line of stonemasons and stone carvers. She took up sculpting when her children went to school and was self-trained until she began working with her brother, Trevor Dring of Phidias Neoclassical in Bristol. Most of her work is commissioned pieces for stately homes and public buildings, especially in Bristol and Bath and for churches. The crest on Bristol Crown Courts and the *Mary with Christ Crucified* for the Belgian War Memorial in Kensal Green in London are her work. Page **57**

Alfred Edward Briscoe Drury RA (1856-1944) By the year Drury was commissioned to make the memorial for Clifton College (1904) he had already designed busts for the garden of Barrow Court, near Barrow Gurney, and this commission for the Gibbs family may have led to connections with the College. Drury had trained at the South Kensington Schools (that later became the RCA) under the French sculptor Aimé-Jules Dalou and worked for him in France. Dalou was a great influence on English sculpture at the end of the nineteenth century. Early in his career he also worked for Sir Edgar Joseph Boehm, the sculptor of the statue of the Bristol Queen Victoria, and he made the memorial to Bishop Trelawny in Bristol Cathedral. In 1906 he modelled four of the colossal figures on Vauxhall Bridge in London. The others were by Frederick Pomeroy, RA. His statue of Sir Joshua Reynolds (1931) at the Royal Academy in London has always been highly praised. Page **32**

Rachel Fenner ARCA (1939 -) Born in Scarborough Rachel first studied at Wimbledon School of Art where she concentrated on life drawing and modelling. When she moved to the RCA she became influenced by minimalism. During a period of teaching in and around London she began to exhibit her sculpture throughout the UK. By 1980 she was appointed City Sculptor to Portsmouth and became interested in public sculpture. The next fourteen years brought many site- specific commissions and she built most of these including reliefs, stone carvings and brick constructions. In 1994 she was Sculptor-in-Residence at St. David's Bishop's Palace. Page **122**

Eric Gill (1882-1940) was an engraver, letter-cutter, sculptor, typographer and writer. He had a number of connections with Bristol including the Chute family. He designed and hand-painted the fascia for the bookshop of his friend, Douglas Cleverdon, at the top of Park Street in 1927. He used sans serif capitals and Fiona McCarthy, Gill's biographer, says Stanley Morison of the Monotype Corporation saw the board and was inspired to commission the world-renowned Gill Sans Serif typeface. Gill was born in Brighton, the son of a clergyman, and studied under Edward Johnston, the designer of the London Transport typeface. In the early part of his career he worked as a letter-cutter and type designer. After 1910 he created a great deal of sculpture – the best-known and largest work was *Prospero and Ariel* on Broadcasting House, in London. The *Stations of the Cross* in Westminster Cathedral are also his and he has work in Tate Britain. Page **44**

George Godwin (1813-88) ran an architectural practice, with his brother Henry, in London. Their major work in Bristol was the restoration of St Mary Redcliffe between 1843 and 1872. Alderman Proctor paid for much of that work. It is not surprising he gave them the commission to design his house, Elmdale (1867) and the drinking fountain (1872) on the Downs. Page **97**

Nicola Hicks CBE ARCA (1960-) was born in London and studied first at Chelsea College of Art, then at the RCA. In her subsequent career she has gained a high reputation for her study of anatomy, the discipline of her drawing, often using charcoal, and for her sculpture of animals for which she has a passion. 'Maybe it's because we are a little less familiar with beasts that I've chosen them.' She has had over 20 solo exhibitions since 1984 in England, Ireland, France, Canada and America and been represented in an even larger number of mixed exhibitions. In 1989 she was Artist-in-Residence at the Yorkshire Sculpture Park when she worked on a project called *Out of Clay*. Her work is in many public collections, including the Tate. Page **124**

Frederick Brook Hitch FRBS (1877-1957) Brook Hitch is an example of the longevity of many sculptors. His father was a monumental mason and he studied under him as well as attending the Royal Academy Schools. He worked in London for most of his life making portrait reliefs and busts. Page **45**

Laurence Holofcener (1926-) Born in Baltimore, Maryland, USA, Holofcener now lives in the Isle of Wight and in Normandy. He is a self-taught playwright, librettist, composer, poet, novelist, director and sculptor. He wrote songs for NBC-TV, the Broadway musical *Mr. Wonderful* with Sammy Davis, Jr. and compiled a rhyming dictionary for songwriters. On Broadway he acted in *Stop the World* and *Hello Dolly*. His sculptures include *Faces of Olivier* in Chichester Theatre and *Thomas Paine* for Bordentown, New Jersey. Currently he is producing portraits of 24 people under the title *20th Century Icons*. Pages **60, 61, and 62**

Graham Ibbeson MA (RCA) (1951-) has been a professional sculptor for over 20 years working with architects and planners to create sculpture for specific sites. He has worked in bronze, steel, stone and fibreglass. He lives and works in Barnsley and he studied at Barnsley School of Art, Trent Polytechnic and the RCA. In 1996 he made a bronze of an early rugby hero, William Webb Ellis, for the centre of Rugby and he has statues in Perth, Chesterfield, Middlesborough and Northampton. In 1992 he completed five relief panels for Eurotunnel at Folkestone. Page **64**

Rev. Reginald Jeffcoat Reports suggest he was eccentric and that he enjoyed his reputation as an artist. At the age of 75 he married his housekeeper and emigrated to South Africa in 1948, leaving most of his extensive library to the University of Bristol. Page **85**

Stephen Joyce FRBS (1956-) lives and works in Bristol and has contributed more work to the streets of the city than any other sculptor. He studied Fine Art at UWE (1976-9). His three major sculptures are displayed in this book and he has made 18 sculptures for three street schemes for Bristol City Council, three viewpoint sculptures for Ashton Court, an adventure playground for St Agnes, Bristol and sculptural railings 35m long for Ystrad Mynach, in south Wales. He was made a Bursary Member of the Royal Society of British Architects in 1998 and he is currently Visiting Arts Lecturer at Bath Spa University. Pages **53, 54 and 116**

Alexander Paul Klecki ING. ARCH SARP (1927-) Born in Poland he was deported by the Soviets to Siberia. From 1942 he lived and was educated in India. Since then he has lived in London. He studied architecture and worked with Sir Frederick Reed on Terminal 3 at Heathrow Airport. In 1965 he won the House of the Year Award with the Architects and Planners Award and he has architecture in Dirab, Saudi Arabia and in Abu Dhabi. He has worked in stained glass. His public sculptures include work in St Andrew Bobola RC church in London and *Christ the King* in aluminium in Newcastle. Page **51**

Gerald Laing FRBS (1936-) has his own bronze foundry at Kinkell Castle in the north of Scotland where he cast the Bristol fountain of *Sabrina*. Among his other major commissions are the statue of Sherlock Holmes (1991), a memorial to Sir Arthur Conan Doyle in Edinburgh, and *Eight Dragons* (1994-5) for the Bank Underground Station in London. Portrait commissions have included Pavarotti, Sam Wanamaker, Tam Dalyell and Andy Warhol. He has held Visiting Professorships of Sculpture in New Mexico and Columbia University, New York. Page **100**

Kate Malone (1959-) was brought up in Bristol and graduated from Bristol Polytechnic in 1982. She now lives and works in London. Her main interest is in ceramics but she enjoys making large-scale work for public places. An exhibition of her pottery was held in the Bristol Museum and Art Gallery in 1999. Page **108**

David Bernard McFall RA ARCA (1919-1988) was born in Scotland. He trained at Birmingham School of Art and the RCA. He was an assistant to Sir Jacob Epstein and became a close friend. The Bristol *Unicorns* were one of his earliest public commissions and he produced a series of portrait busts. Among the best-known were of Clement Attlee (1965) and Vaughan Williams (Royal Festival Hall 1957). He made an over-life-size statue of Winston Churchill (1959) at Woodford Green, Essex. McFall fought a rare form of cancer for the last seven years of his life and he made a bronze Christ for the precinct of Canterbury Cathedral that was unveiled three months after he died. Page **88**

William McMillan RA ARCA (1887-1977) was born in Aberdeen where he first went to art school before attending the RCA under Professor Lantéri. He worked in London for many years, specialising in figures and groups, and he was one of the youngest sculptors to be elected ARA. He was Master of Sculpture at the Royal Academy Schools from 1929-1940. The bronze fountain on the east side of Trafalgar Square is his. The Haig statue was a relatively early commission in a long career – he lived to ninety. His statue group of Alcock and Brown at Heathrow was not made until 1966. Page **41**

Paul Mount ARCA RWA (1922-) has made sculpture in stainless steel, bronze, concrete and GRP. He was born in Newton Abbot and educated at the grammar school there. He then studied at Paignton School of Art and the RCA. He has had many one-man shows in the UK and abroad and he has made architectural sculpture for Nigeria, Ghana, London and Cardiff. Paul Mount taught at Winchester School of Art from 1948-55 and now lives in St Just in Cornwall. Page **114**

David G. Mutasa was born in Zimbabwe. In 1987 he held an exhibition of his work at St David's Hall in Cardiff while he was working on the Fagon commission for several months. His visiting scholarship to the UK was financed by The British Council. He has made several sculptures commemorating heroes of Zimbabwe who fought for independence. These were displayed at the Parliament Buildings in Harare and he was commissioned to make a memorial to Samora Machel. Page **55**

Charles James Pibworth ARCA (1878-1958) was born in Southville and studied at Bristol School of Art. From there he went to the Royal College of Art and the Royal Academy Schools in London in 1899. He carried out a number of works for Charles Holden during the first decade of the twentieth century, including figures on the Law Society in Chancery Lane in London and a relief, *Euterpe*, in Archer Street. A report in the *Western Daily Press* in May 1922 showed three busts by Pibworth that had been exhibited at the Royal Academy. Page **83**

Henry Poole RA (1873-1928) was born in Westminster, the son of an architectural sculptor and he trained at Lambeth School of Art and the Royal Academy Schools under Harry Bates and G. F. Watts. His association with the architect E. A. Rickards was long and productive. They worked together on municipal architectural projects, similar in scale to the Edward VII Memorial, where Poole's

sculptural skills were used very effectively – Cardiff City Hall, Deptford Town Hall and the Central Hall, Westminster. Poole worked on the Edward VII Memorial for seven years and thanked the Mayor's Secretary, J. H. Reed, for his loyal help by sending him a bronze cast of his maquette. Page **36**

Niranjan Pradhan (1940-) lives and works as a painter and sculptor in Calcutta. He studied at the Indian Government's Art College in that city and now teaches there. He has work in Delhi, Bombay and Calcutta. He works exclusively in the Western tradition but much of his work in the 1990s was abstract and he is an admirer of Barbara Hepworth. A bust he made of Rammohun Roy in 1995 is in the foyer of the Bristol Council House. Page **59**

William Pye (1938-) has made a very specialised contribution to public sculpture by exploring the qualities of water in most of his major commissions. He is quoted as saying the addition of water gives sculpture a mesmeric quality to which people respond sympathetically. His early training was at Wimbledon School of Art and at the RCA.
At Gatwick Airport he has *Slipstream and Jetstream* (1988), in the centre of Derby *Cascade* (1995) and in the same year *Water Pyramid* in Paris as well as public works in the USA and Japan. Page **109**

John Randall (fl.1723). The only information about him is contained in the Bristol Record Office document that says he was paid for 'the Figure Neptune and Peddistoll'. That only suggests he was the founder, not the sculptor, and no record of any other sculpture by him has yet been found. A Bristol newspaper, dated 22 December 1787, *Sarah Farley's Bristol Journal* says specifically, 'It (Neptune) was *cast* by Randall'. Confusingly a Poll Book of 1734 names 'Joseph Rendall' as a founder in Bristol. That is the spelling on the present plaque. Page **69**

Peter Randall-Page (1954 -) was born in Essex but within two years his family moved to Sussex. He studied at Bath Academy and then worked for two years with the sculptor Barry Flanagan. His work in the exhibition 'On Site' at the Arnolfini in Bristol in 1977 was the first occasion his sculpture was seen in public. In 1979 he worked on the conservation of thirteenth-century sculpture on Wells Cathedral and in 1980 he won a travelling Fellowship to study marble carving at Carrara in Italy. Since that date he has had many exhibitions throughout the UK. He became a Visiting Lecturer in Sculpture at the RCA in 1993. Page **107**

W. R. Ritchie (1919-1997) After studying at Coventry School of Art Ritchie became a pupil of Eric Gill whose work and influence became very important to him. One of his obituaries described him as 'intensely individual'. He only used direct hand carving – a technique that he could handle alone. Any method that involved an assistant or an industrial process was dismissed. Once a commission was started he worked without regard to cost. He wrote 'From the time I first began to practise . . . I wanted my work to be for buildings or "in the street" rather than in art galleries'. Page **118**

John Michael Rysbrack (1694-1770) Rysbrack's life is well documented. He was born in Antwerp where his father, Peter, was a landscape painter and he trained under the sculptor Van der Voort before he came to England in 1720. His reputation was very high and the *Dictionary of British Sculptors* by Rupert Gunnis (1951) says 'Rysbrack was the acknowledged head of his profession and he reigned unchallenged until Peter Scheemakers carved his statue of Shakespeare for Westminster Abbey' (1741). The trio of foreign sculptors – Rysbrack, Scheemakers and Roubiliac, dominated the early Georgian scene. Bristol has Rysbrack's monument

to Colston in All Saints Church, Corn Street (1729) and at Stourhead there are his marble statues of *Bacchus* (1751) and *Hercules* (1756). Bristol Museum and Art Gallery holds his terracotta busts of Edward Colston and Anthony van Dyck. Rysbrack's work can also be seen at Chiswick House – statues of Palladio and Inigo Jones, and at Stourhead. He made an amazing range of busts of famous men – Sir Isaac Newton, John Locke and Oliver Cromwell. For many years he had studios in Vere Street, off Oxford Street in London where he died. He was buried in Marylebone churchyard. Page **16**

Andrew Smith MA (RCA) (1962-) was born in south Wales and attended art courses in South Glamorgan and then West Surrey College of Art and Design where he gained a BA(Hons) in three-dimensional design, specialising in metals. He then spent two years at the Royal College of Art in the Department of Metalwork. After research travel to Berlin, Paris and Iran he has worked as a designer of street furniture. Between 1984 and 2002 he exhibited in London, Edinburgh, Cardiff, Tokyo and Los Angeles. He has gained many commissions for public sculpture and has work in Milton Keynes, Rotherham and Kensington. He is now in freelance practice in London. Page **127**

Keir Smith (1950-) lives and works in London. The inspiration of much of his work has been an abiding interest in Renaissance church art, both painting and sculpture, in northern Italy. The church of San Sigismondo, near Cremona has been central to this. In 2000 he made a memorial in bronze and stainless steel, 4.5 metres high, at the Ironbridge Museum in Shropshire. This is called *A Flower in Flower* and is dedicated to Roy Kitchin, his sculpture tutor. Among his other sited sculptures are works in the Forest of Dean, the Surrey Hospital, Guildford and in the Sculpture Park at

Goodwood. In 1986 he had work in the Arnolfini gallery and his first solo exhibition *Ognissanti* was at the Barbican in 1988. Page **121**

William John Smith (1862-1936) was probably born in Bristol. He attended Queen Elizabeth Hospital School and in later life he lived in the Montpelier area of the city. Half a century after his death the Bristol *Evening Post* noted the anniversary and described him as 'One of the City's finest sculptors and ecclesiastical carvers'. He worked on the University, the Cathedral and St Mary Redcliffe Church as well as the Museum and Art Gallery. While working in America he carried out carving on a house being built for the Vanderbilts and won some national trophies for cycle racing. Page **82**

James Havard Thomas (1854-1921) was born in Bristol of Welsh parents and he first studied at Bristol School of Art before going to the Ecole des Beaux-Arts in Paris. From 1889 to 1906 he lived and worked in Naples, Pompeii and Capri where he made a close study of Greek bronzes. This led him to make statues based on the Greek model and his *Lycidas,* now in Tate Britain at Millbank, is in this style. He became a master of bronze founding and his statue of Burke was cast in Naples. He declined to enter the competition for the King Edward VII Memorial on the grounds that he had two statues in Bristol and was too established to compete. From 1911 he taught at the Slade School and became Professor of Sculpture there in 1915. Against the trend he took pride in carving his own work. In the latter part of his life he lived at The Manse, at Shrivenham in Berkshire. There are three memorials in Bristol Cathedral with sculpture by Havard Thomas – they are Mary Carpenter, Samuel Morley and Frederick John Fargus, 'Hugh Conway'. His *Head of a Young Boy* can be seen in the city's Museum and Art Gallery. Pages **24** and **28**

John Thomas (1813-1862) was born at Chagford, Gloucestershire and he was apprenticed to a stone mason when he was orphaned. He went to Birmingham where his brother worked as an architect. This led to a large commission, from Sir Charles Barry, to work on Birmingham Grammar School that took three years. His output was immense and he also worked as an architect. In 1923 the Bristol Museum and Art Gallery purchased a plaster cast of *Musidora* but that was unfortunately destroyed in the Second World War. Pages **22** & **78**

Philippa Threlfall (1939-) and **Kennedy Collings** (1933-) This husband-and-wife partnership, based in Wells, has been making ceramic sculpture for nearly thirty years with sculpture in banks, airports, offices and shopping developments. They have other works in Bristol – twelve reliefs on Broad Quay House (1981) telling the history of Bristol, ceramic panels on the Friendly Society building in Colston Street (1994-5) and terracotta panels on the first floor of Froomsgate House. Philippa studied ceramics and graphic design at Cardiff College of Art and Goldsmiths' College in London. Kennedy was born in Bristol and was educated at Clifton College before he read History and Law at Cambridge. He then worked in industry before going into the partnership. Their company is called 'Black Dog of Wells' after the medieval name of their studio workshop property on Wells Cathedral land. Page **105**

Simon Thomas ARCA (1960-) Born in Portsmouth, the sculptor has been based at studios on Spike Island, Bristol since 1997. He was appointed Artist-in-Residence at the University of Bristol's Physics Department in 1995 and has worked closely with Hewlett Packard. He has exhibited at the Royal West of England Academy. Page **63**

Paul Vincze ARBS (1907-1992) Vincze's reputation was based on his work as a medallist and it is not surprising to see why he gained the commission for the Holden plaque. He was born in Galgagyork, Hungary and studied at the State School of Arts and Crafts in Budapest before working with E.Telcs from 1924 to 1935. Following two years further study in Rome he came to England in 1937. He exhibited widely in Britain and the Continent showing medals, bas-reliefs and some sculpted busts. Page **46**

Arthur George Walker RA (1861-1939) exhibited a statuette of his John Wesley statue at the Royal Academy Summer Exhibition in 1934 – two years before he was elected RA. He made public statues of the famous nineteenth-century figures Emmeline Pankhurst in the Embankment Gardens and Florence Nightingale in Waterloo Place, SW1, London. He was born in London, the son of a shipping merchant, and he studied at the Royal Academy Schools. In his later years he lived at Parkstone, Dorset and when he died the Bristol Wesleyans published an obituary praising him for his modesty and integrity of character. Page **42**

David Ward (1951-) Initially a painter, his work has developed to involve a range of media that includes photography, dance, performance, sound, light and glass. He studied at Wolverhampton and Winchester Colleges of Art. Since 1991 he has served various terms as Artist-in-Residence at King's College, Cambridge, the Cambridge Dark Room, Harvard University and Durham Cathedral. He gained a Research Fellowship at the Henry Moore Centre for the Study of Sculpture, Leeds, in 1996. He has taught at Goldsmiths' College and currently teaches at the Architectural Association and Westminster University. He has public work in Coventry, Wolverhampton and Lowestoft. Page **126**

Musgrave Lewthwaite Watson (1804-1847) Watson's biographers praise him and feel the sculptor would have attained much greater fame had he not died so young. Born at Hawkesdale in Cumbria, he went to London in 1824 to attend the RA Schools and spent two years of study in Rome. He became an assistant to a number of the best sculptors of the early nineteenth century. Among them were Flaxman, whose statue on the RWA now gazes on his student's work, and E. H. Baily. The link with Baily may have brought him the Victoria Rooms' commission. Page **74**

Sir Charles Wheeler RA ARCA (1892-1974) was born at Codsall in Staffordshire, studied at Wolverhampton School of Art and the Royal College of Art, under Professor Edouard Lantéri, where he met a fellow student, William McMillan, the sculptor of the *Haig* statue at Clifton College. Wheeler worked mainly in architectural sculpture and portraiture. He had a long career – his first commission was a *Madonna and Child* (1924) for Winchester College. This was followed by one of his best known works, a series of figures for the Bank of England (1930). As late as 1975 his last public work, *Mary of Nazareth*, was set up in St James's Church in Piccadilly, the year after he died. For ten years (1956-66) he was an effective President of the Royal Academy, the first sculptor to be elected to that post, and he was knighted in 1958. Page **90**

Onslow Whiting (fl.1895-1933) was a London sculptor whose other work included a representation of field guns in action at Colenso in the Boer War. In 1902 Whiting made three of the four relief panels at the base of the obelisk erected on Plymouth Hoe. This memorial was to the Officers and Men of the Gloucestershire, Somerset and Devon Regiments who fell in the Boer War and to HRH Prince Christian Victor of Schleswig-Holstein, one of

Queen Victoria's grandsons. The Plymouth memorial's link with the Gloucestershire Regiment probably led to Whiting gaining the commission for the Bristol statue. Page **34**

W and T Wills (*fl.*1856-1884) This London partnership of brothers had studios at 12 Euston Road. They worked closely with the Coalbrookdale Iron Foundry and specialised in cast iron drinking fountains, similar to the Bristol model. Liverpool and London share an identical drinking fountain made by them. Among larger-scale works, they made the statue of *Richard Cobden* (1866), the MP and Free Trade and Corn Law reformer, in Camden Town, London and, in the West Country, the marble statue of *Henry Edwards* (1886), Weymouth's MP for 18 years. Page **96**

Vincent Woropay (1951-) won a scholarship to study at the British School in Rome at the end of his three years at the Slade School of Art (1979-81). He has work in various international collections as well as large-scale works in public – *Hand of Mithras* in Stoke-on-Trent and two works in Birmingham, *Wattilisk* (1988) and *Construction* (1990). He is a visiting lecturer in a number of art colleges. Page **103**

Acknowledgements

I am grateful to the Public Monuments and Sculpture Association (PMSA) for agreeing to the use of the research material gained during their National Research Project and for their permission to reproduce photographs taken in the course of that survey.

With the encouragement of the PMSA Francis Greenacre, then Curator of Fine Art at the Bristol Museum and Art Gallery, initiated a survey of Bristol's public sculpture in 1995.

The project was very generously supported by the trusts of two Bristol residents, Richard Lalonde and Jay Tidmarsh. Their vital support became a crucial component of the PMSA's successful application to the Heritage Lottery Fund for a nation-wide survey of public sculpture.

Subsequently, Dr. Paul van der Lem and Dr. Paul Gough, through the Faculty of Art Media and Design at the University of the West of England arranged additional funding to support the PMSA survey of the whole of the South West Region.

Practical help with research came from many sources. Dr Pat Prior generously made her excellent study of the statue of *Neptune* available to me. I have frequently quoted from the published writing of the Bristol architect Mike Jenner and he also gave valuable assistance. Godfrey Laurence kindly read all the text and gave detailed information on Edmund Burke. Jo Casey, John Toplis and Derek Sagar did voluntary work on the PMSA survey and their contributions were of great value. Garry Reeder, Senior Surveyor of Bristol City Council, has given advice on monuments in the Council's care.

Over the past five years Anthony Beeson and his colleagues at Bristol Central Library have unfailingly helped in the search for information on all aspects of Bristol sculpture.

Bristol Record Office provided a service of the highest standard on all occasions and I thank John Williams and his staff. The BRO's documents on the creation of the King Edward VII Memorial were of particular help.

Sheena Stoddard and Karin Walton at Bristol Museum and Art Gallery searched many facts on my behalf.

Dr John Physick, past Curator of Sculpture at the Victoria and Albert Museum and Edward Morris, until recently Curator of Fine Art at the Walker Gallery, Liverpool, gave advice from their deep knowledge of the subject.

Recent research by Mike Pascoe uncovered information on the Emma Saunders' memorial and the Simon Short fountain that had not surfaced for many years and I am delighted to include this in my text.

John Sansom came to me with a concept for this book and throughout its preparation he has been a patient and meticulous editor.

I began working with Adrian Ball in Fleet Street in 1964. Our company produced the publicity for the return of the s.s. *Great Britain* to Bristol and he had great affection for the city. He died in 1989. He would have been pleased, and no doubt amused, to know this book had been produced.

Janet Margrie, my partner, took most of the photographs while working with me on the PMSA survey and she has borne constant repetition of the text with wonderful grace on many occasions.

DM March 2002

The Victoria Rooms and Tyndall's Park

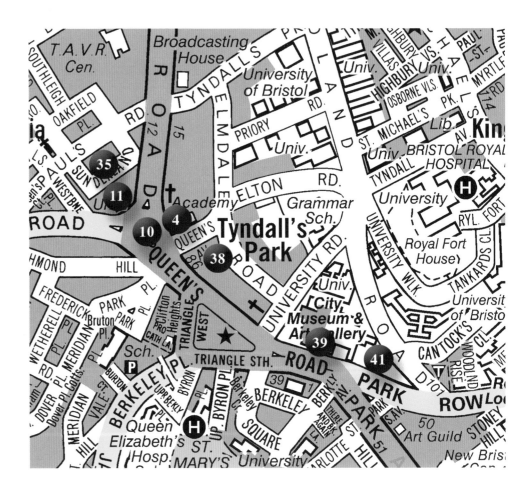

City Centre

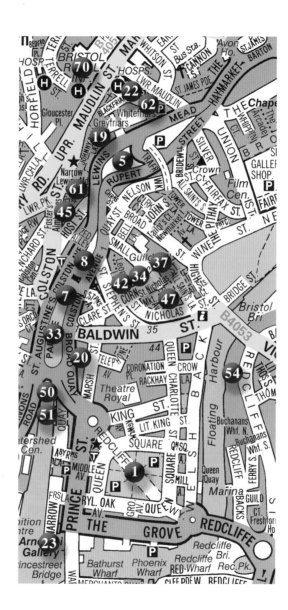

College Green and Millennium Square

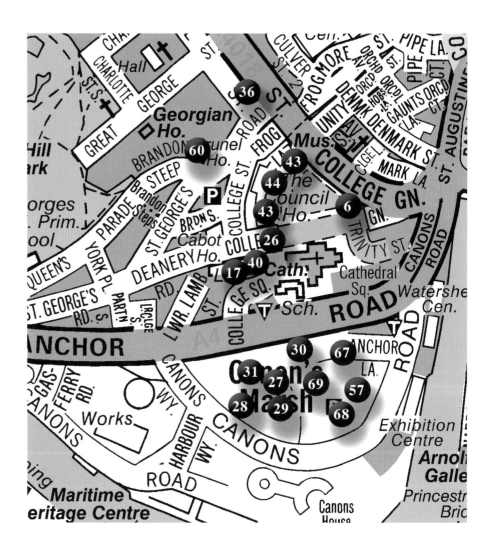

Castle Park and Temple Meads

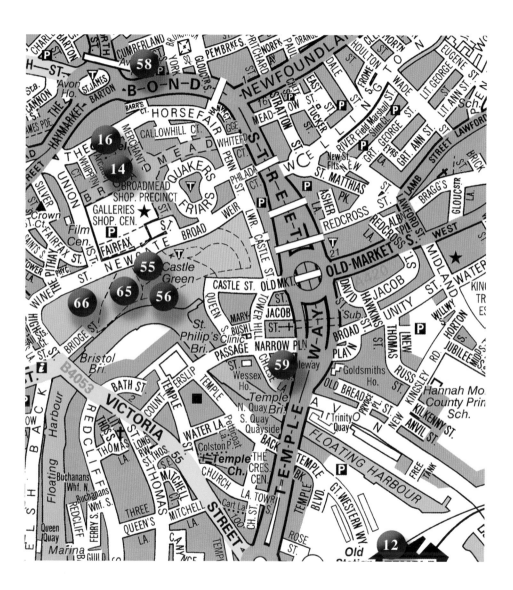

Clifton and Hotwells

These maps are not to scale
and they only show the 70 works
listed in this book

Sculpture sited off the area of the maps

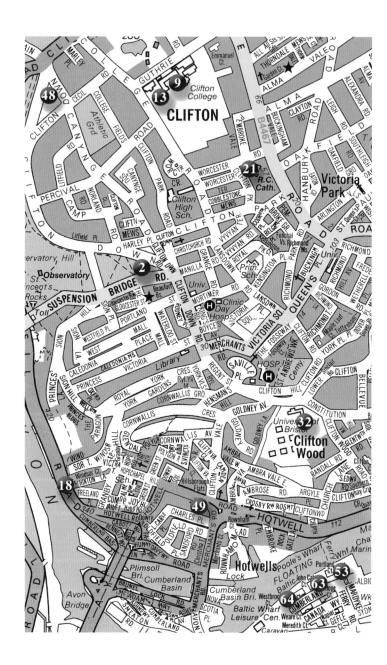